Harker's Barns

A Bur Oak Book

Harker's

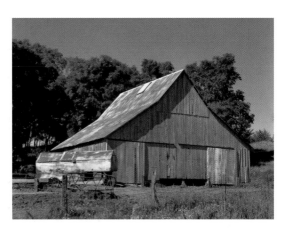 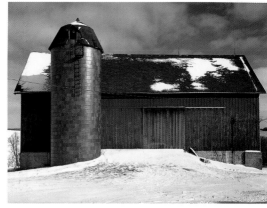 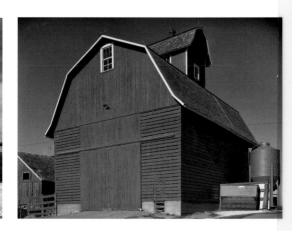

Barns

Visions of an American Icon

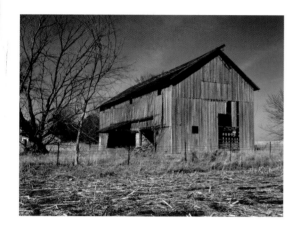 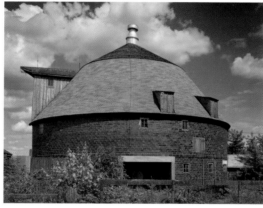 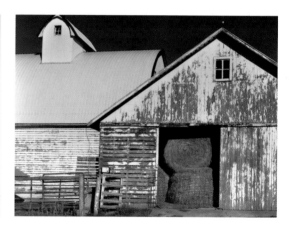

Photographs by **MICHAEL P. HARKER** Text by **JIM HEYNEN**

UNIVERSITY OF IOWA PRESS ψ IOWA CITY

University of Iowa Press, Iowa City 52242
Printed in China
Design by Richard Hendel
http://www.uiowa.edu/uiowapress

The publication of this book was generously supported by
the University of Iowa Foundation.

Printed on acid-free paper

Library of Congress Cataloging-in-Publication Data
Harker, Michael P., 1950–
Harker's barns: visions of an American icon / photographs by Michael P. Harker;
text by Jim Heynen.
 p. cm.— (A Bur oak book)
ISBN 0-87745-834-0 (paper)
1. Architectural photography—Iowa. 2. Barns—Iowa—Pictorial works.
I. Heynen, Jim, 1940–. II. Title. III. Series.
TR659.H373 2003
779'.4777'092—dc21 2002027191

03 04 05 06 07 P 5 4 3 2 1

Dedicated to my wife, THERESA ANNE HARKER

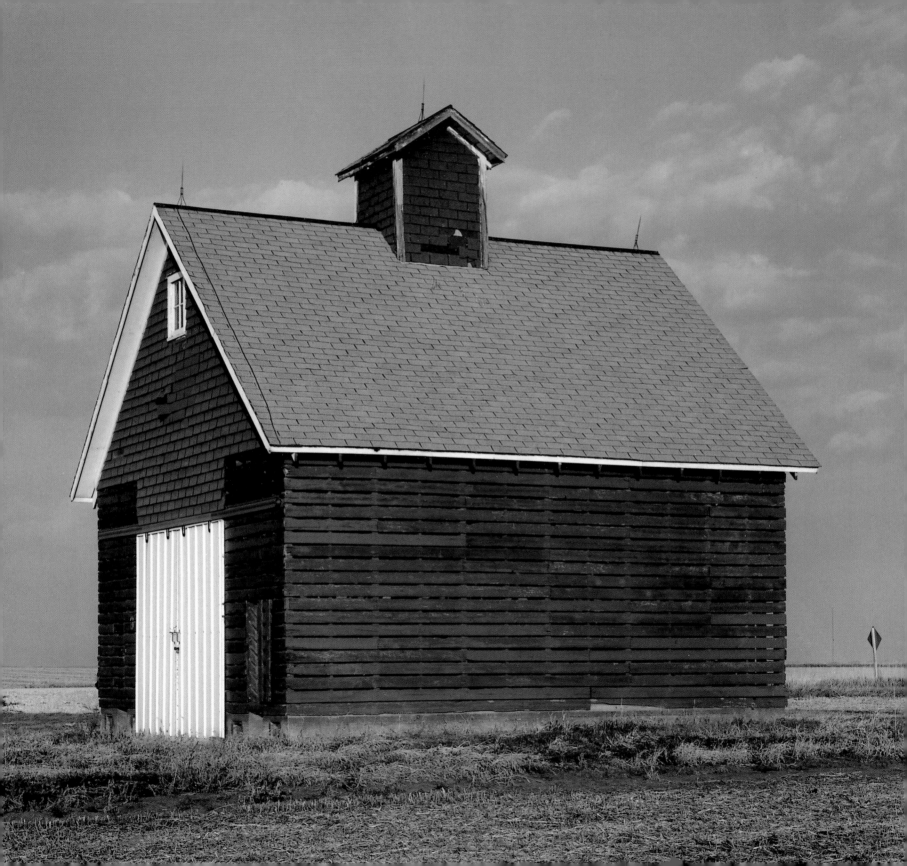

A GOOD PHOTOGRAPH

can maintain an old barn

through blizzards and hail storms and tornadoes.

It is the best support beam and wood preservative

an old barn can have. — Jim Heynen

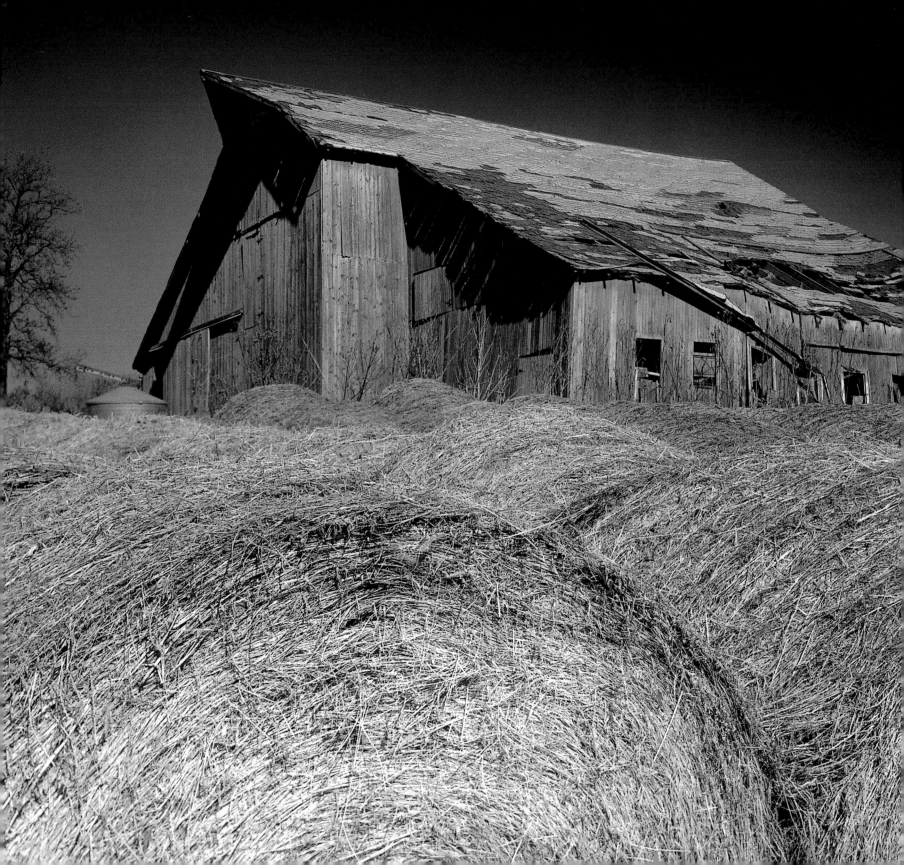

CONTENTS

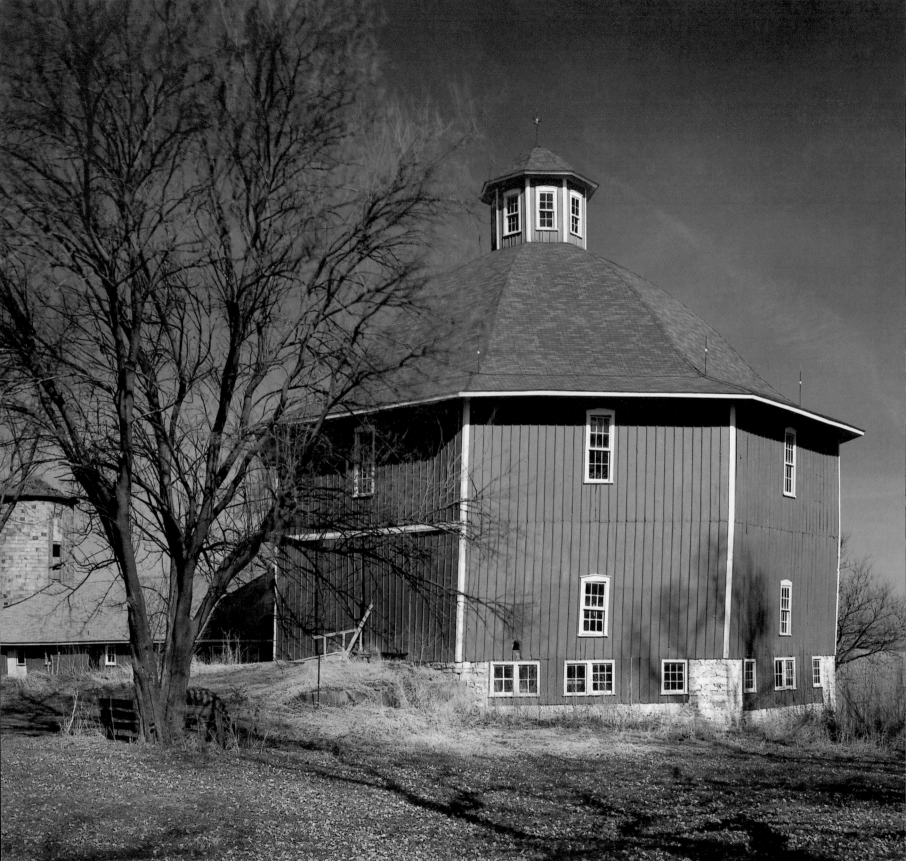

PREFACE AND ACKNOWLEDGMENTS

MICHAEL P. HARKER

Have you ever driven by an old barn on a dusty country road? If so, did you look at it closely as you went by, or did you dismiss it as just another obsolete outbuilding? I have been driving by old barns on gravel roads and blacktop highways for over ten years. I used to dismiss them myself until one day in November of 1993. I was pheasant hunting near Clutier, Iowa, when I drove past a farm that had a windmill vane mechanism leaning against the side of a very rustic barn. The oval shape of that steel object juxtaposed against the weathered wood leaped out at me. I stopped and asked permission to come back the next week with my camera and later captured a very compelling image on black-and-white film.

The photograph *Windmill* was the genesis image that encouraged me to further explore barns as material for my fine art photography. Over the next couple of years I slowly involved myself with barns. I considered them quaint, and I had nostalgic memories of childhood expeditions into friends' barns – rope swings in hay lofts, cows and pigs rolling in mud, sheep and horses in the pastures.

Within two years, however, my photographic exploration of barns led to the realization that Iowa's barns were disappearing, and with them a way of life. Today, Iowa is losing about one thousand barns a year to decay, fire, storms, and corporate indifference to the past. In fifty years, if this trend continues, very few of the barns will be left.

In 1996, drawing on my training and nearly twenty-five years of experience as a professional photographer, I began to design a documentary project. By the spring of 1998 I had carefully considered the parameters of the images I would make and how best to bring what I was doing to the attention of the people of Iowa, who seemed unaware of just how fast Iowa's barns were being lost. I thought that giving lectures with slide shows and having public exhibits of my photographs would reveal changes that were indeed occurring. I was convinced that a book of photographs would be the best medium for showcasing my documentary. That is the purpose of *Harker's Barns*.

The simple expediency of approaching farmers to ask permission to go on their land to take my photographs led to many conversations about their barns. The farmers had both pride in their families' agricultural records and sadness that changes in the economy and modern methods of agriculture were ringing a death knell for the viability of barns. Each barn I photographed reflects the plight of an individual farm operation, and I believe that the whole series of images serves as a reminder of the extent of the economic hardships intrinsic to family farming. *Harker's Barns* is designed as a visual record of old barns – and a few additional outbuildings – on family farms. By portraying the icon of agrarian life, I hope to reveal what more than a century of use has done to these structures and to imply what farmers have experienced.

When the barns were being built from Iowa's native hardwoods (oak, hickory, walnut) – and in some cases from stone and brick – the cultural sphere of farming placed great emphasis on the people and how they as individuals dealt with the many problems of how to be successful. Very little formal training was available to Iowa's earliest farmers; whatever successful technique was applied on any one farm would be handed down from father to son. Trial and error slowly enhanced what was applied. Most of the barns built between 1860 and 1950 were constructed with the agricultural methods of a particular farmer in mind. Each barn had its own unique personality in detail, design, and ethnic heritage. There are Dutch, Czech, German, Swedish, and English traditions recognizable in different areas of the state where people from these countries settled on the land.

I believe my photographs can take on the role of a visual museum, preserving our heritage for future generations. I am motivated and inspired to create this record by the work of the Farm Security Administration photographers who, during the Great Depression, under the auspices of Roy Stryker, recorded life in rural America. They helped save our farmers more than seventy years ago by creating public awareness through photographs published in magazines and newspapers.

My hope is that a serious, definitive group of images of the barns of Iowa can accomplish a similar revival for farming here in the twenty-first century.

I would like to gratefully acknowledge my respect for the special people who have made *Harker's Barns* possible:

Paul Ingram, my agent, for introducing me to Holly Carver and Jim Heynen.

Holly Carver, director of the University of Iowa Press, for her complete encouragement and acceptance of my work for publication.

Jim Heynen, for writing an incredible introduction and setting the tone for the photographs.

Hans Jurgen-Heider, Mannheim, Germany, my first tutor and mentor, for starting me on the long journey to this book in July of 1971, while I was in the U.S. Army.

David Gilmore, Charles Swedlund, Gareth Goodger-Hill, and William Horrell, my professors at Southern Illinois University from 1973 to 1976.

And some very special people who through their friendship were there to encourage me during my many years of growth:

Richard Keeley, my friend and mentor my entire adult life.

Paul Ash, Michael DuPre', Deborah Lampert, Richard Auchter, James Roberts, William Weiman, Louedna Bunker, Gregory Binder, Molly Teigland, John Ellis, Don Misel, John Cox, Dana McGillan, Chris Rossi, Tom and Helen Simmons, Gary Bell, Bruce Bowman, and Randy Peterson.

Theresa Anne, my wife and most ardent supporter, and Emma Rose, my daughter and astute critic of each barn photograph I have taken.

But most of all, a thank you to all the wonderful family farmers of Iowa who so graciously permitted me to set up my camera on their land to document their beautiful, soulful barns.

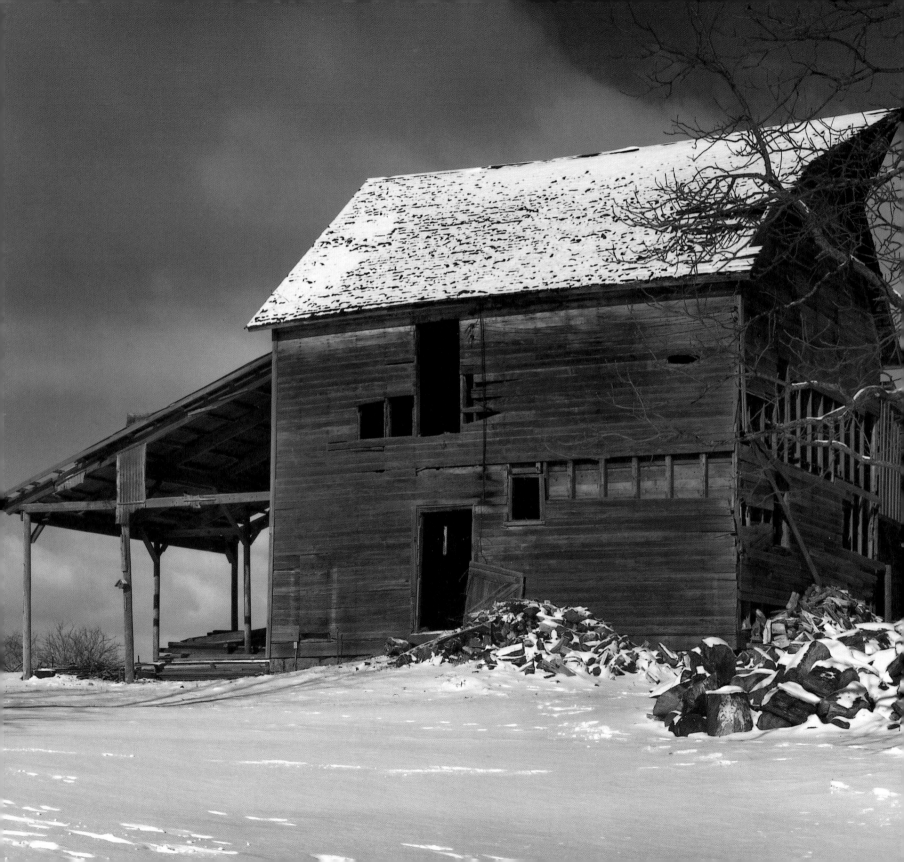

Harker's Barns

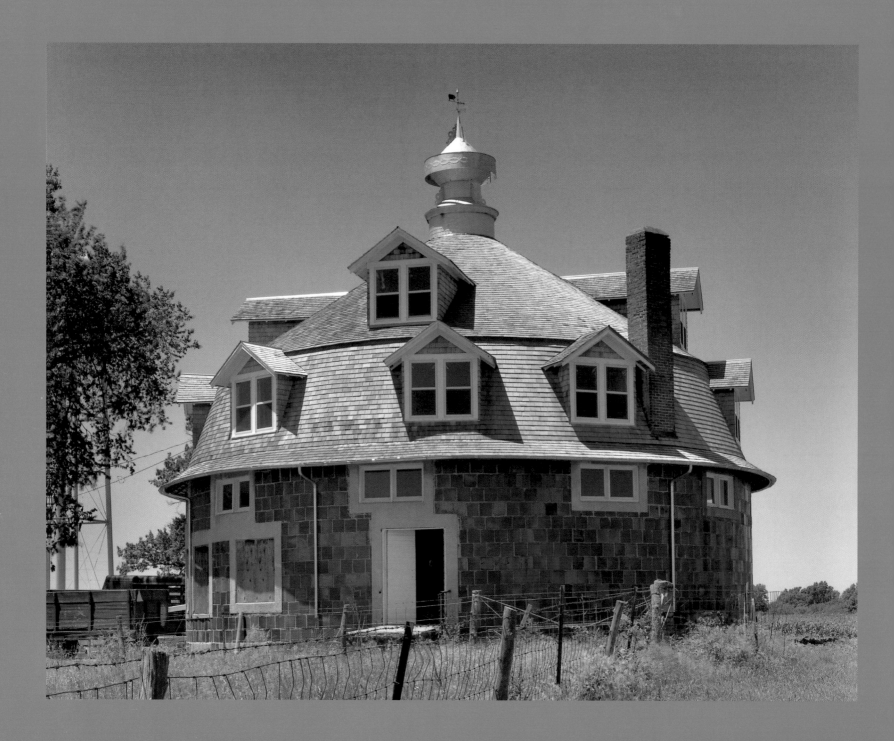

AN INTRODUCTION

JIM HEYNEN

Capitol buildings have a way of asserting themselves. They tell us they are important, that their very structures represent a whole county, a whole state, a whole country. Barns are the capitol buildings of a farm. The cupolas are the capitol domes. And inside their chambers, the serious business of the entire farm operation comes together. Without a barn, the farm has no center. It has no sense of itself.

Few farmers outlive their barns. That's one reason we feel strange when we look at an old barn. It's not really like looking at a tombstone, which can summon our sadness for somebody who is gone; it's more like looking at a dusty encyclopedia on a library shelf, sitting there with that bold patience – as if waiting for something, maybe for the chance to tell its stories. If an old barn makes us think of the first people who built and used it, our minds soon move on, curiously, to the barn itself and what it might have to tell us.

An old barn is layered with history. It is layered with stories. Sometimes it tells about the people who built it, about their lofty or modest ambitions. It carves little messages in the paint and repaired door latches. It tells about animals, too, with its support posts rubbed as smooth as finished furniture. It tells about grains and silage and hay, sometimes dropping seeds that reproduce outside its walls for years. It tells about mangers and storage areas where feed and fresh milk were stored. It tells about birds and rodents in the leftover nests. If it has a stone foundation, it tells about the surrounding land from which the stones were scavenged. The closer we look, the more we will see, the more we will hear.

Wickfield sales pavilion, Cantril, Iowa, 2001

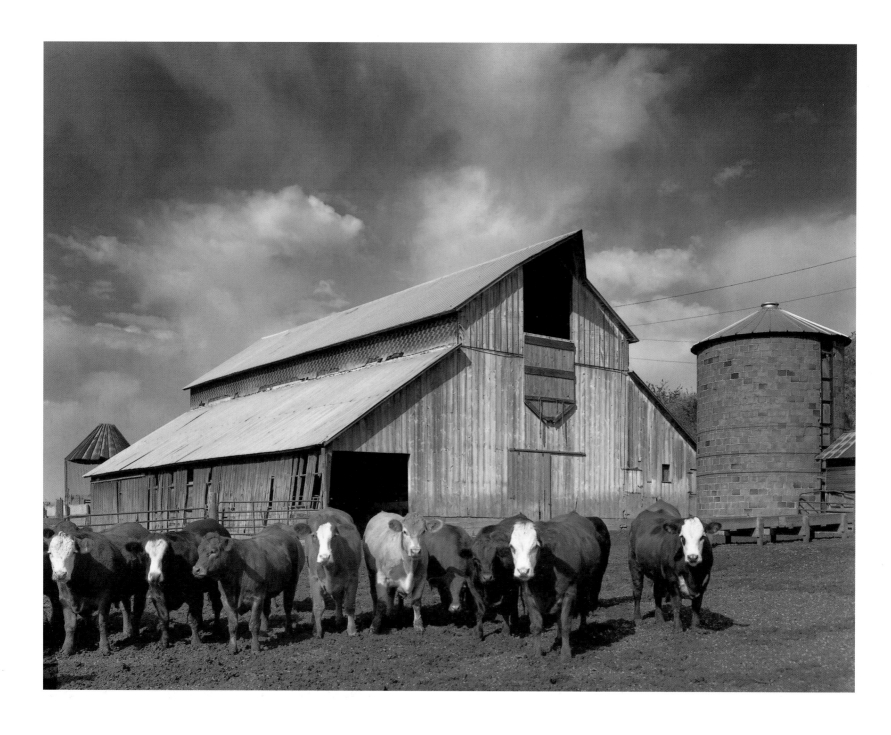

Cows and barn, Bertram, Iowa, 1999

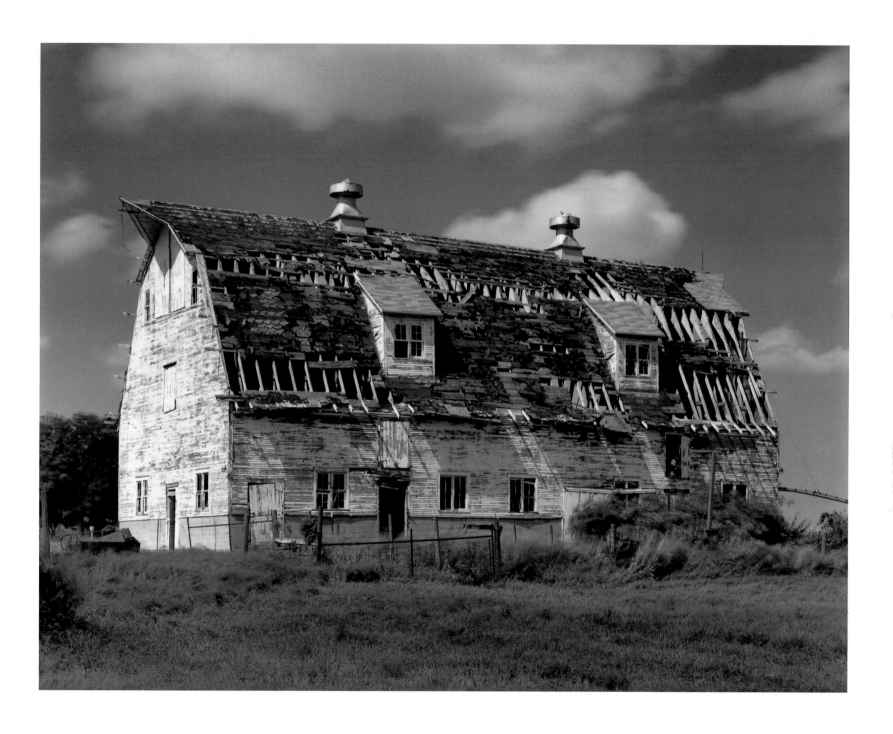

Before the demolition, Newhall, Iowa, 2000

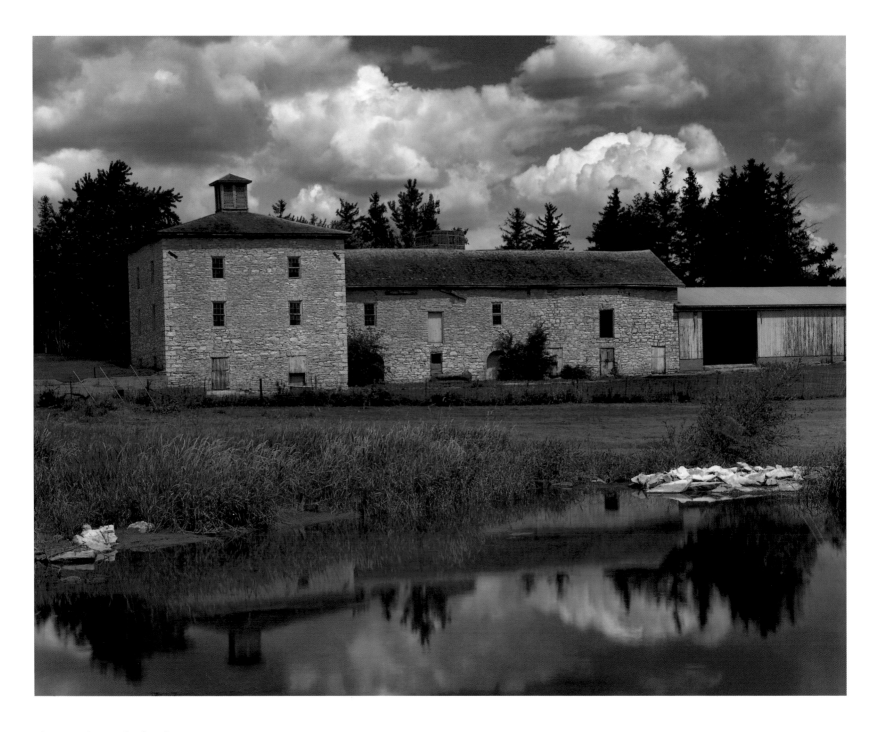

Limestone barn, Charles City, Iowa, 2000

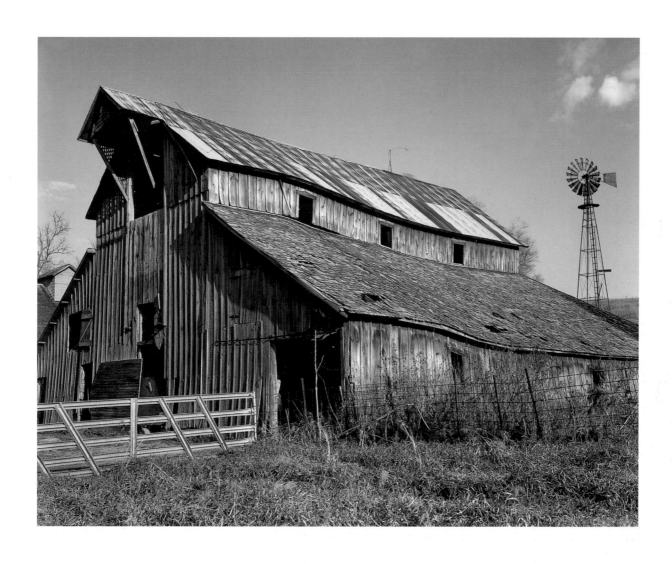

Barn and windmill no. 2, Chelsea, Iowa, 2000

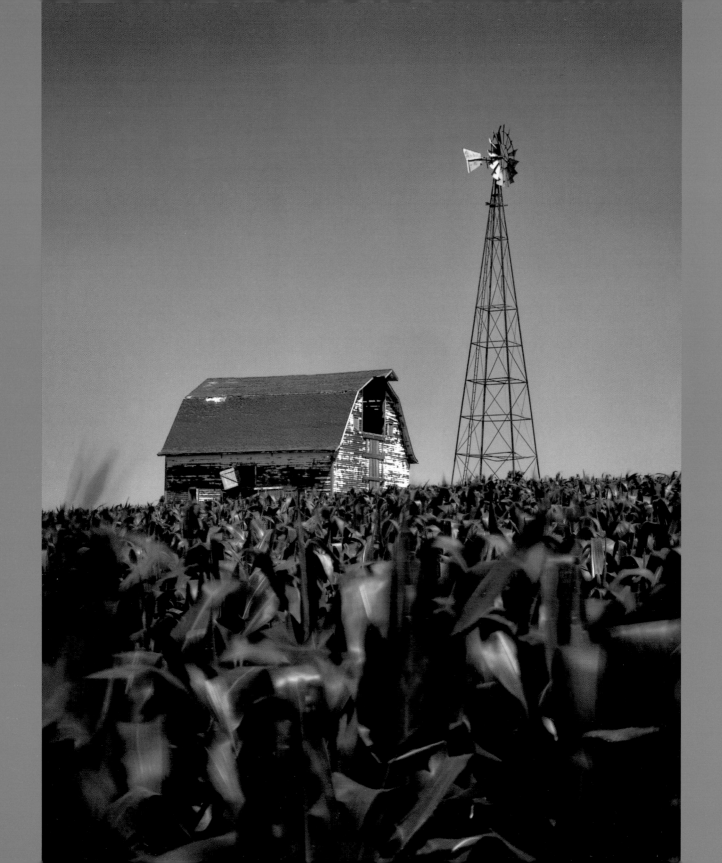

WHAT ARE THESE THINGS?

 What are these things clinging to the landscape, some like broken teeth trying to take a last bite from the sky, some pretending to be old cattle mansions with their gables and huge-hinged doors, some already half skeletons with the last bits of skin refusing to let go? What do they think they are anyhow, permanent residents? Have they no sense of progress?

Barn and windmill, Mechanicsville, Iowa, 1998

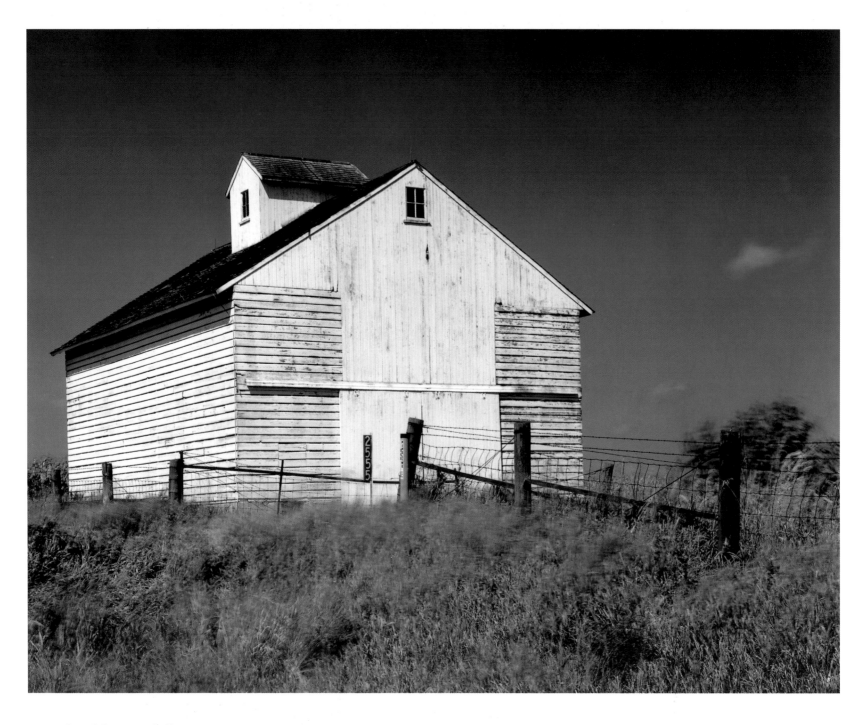

Corn crib and fence, Newhall, Iowa, 2000

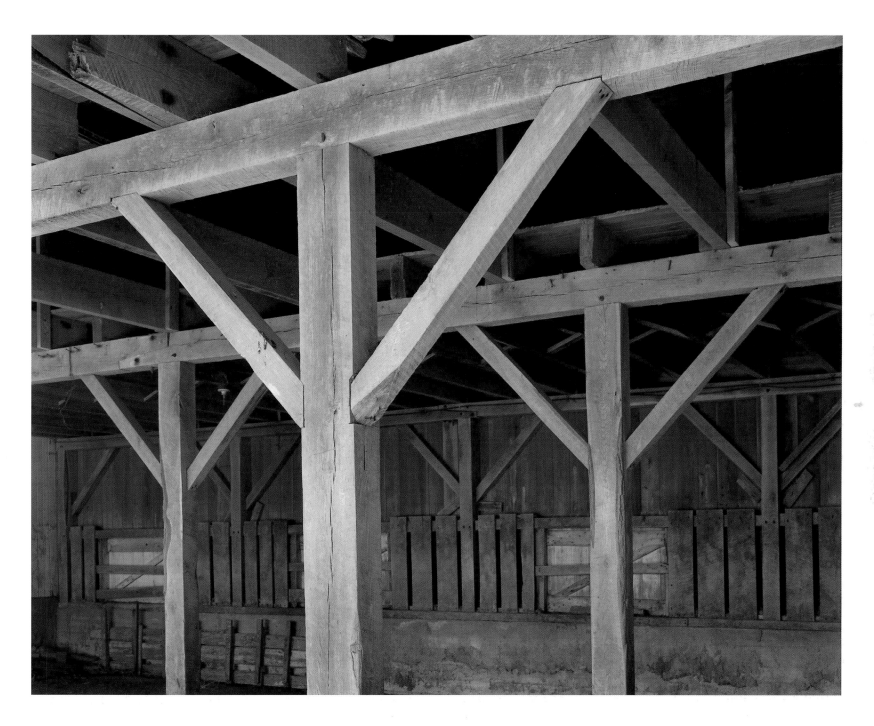

Interior Y-beams, Mount Vernon, Iowa, 2001

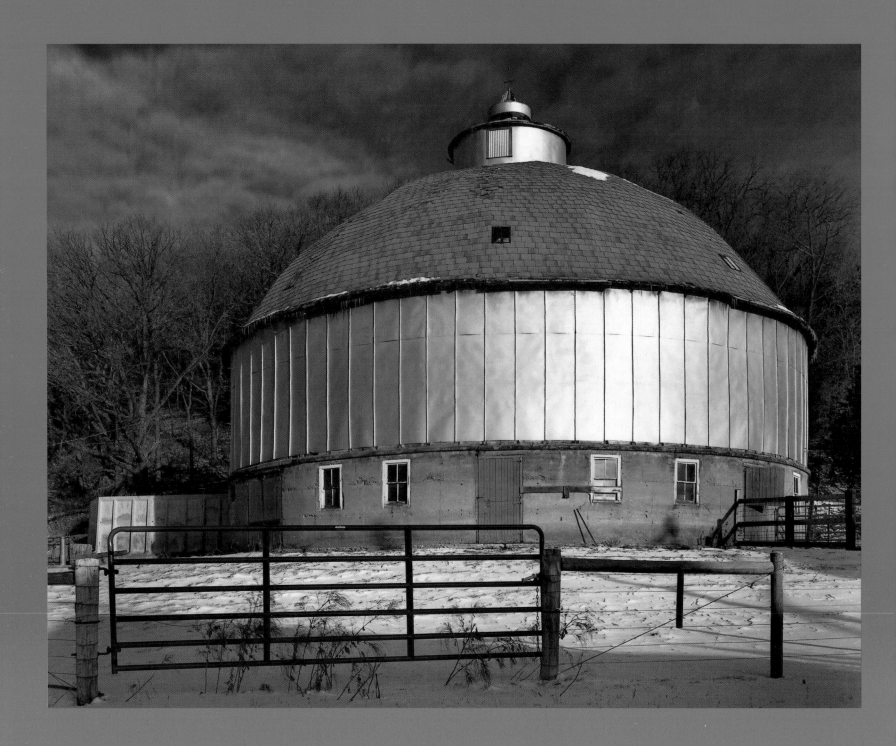

Rural Joke:
Hear about that farmer with the round barn who went plumb crazy?
What happened?
He couldn't find a corner to pee in.

The round barn was conceived in a den of boredom. In a den of boredom and in a romantic memory of some ancestors who did something dramatic and round somewhere a long time ago. Or no, it may have been conceived in a flourish of rebellion, forerunner of Buckminster Fuller's dream of the geodesic – at least of something in harmony with the round structures of the universe. A symbol of eternity. A wedding ring of commitment to good husbandry and an emphatic statement against squareness.

Windows in a round barn follow the light of the seasons, thus giving a sense of agreement with nature.

Round barns are more fun for games of tag and hide-and-seek.

Builders don't get bored building a round barn.

Round barns give young animals a sense of freedom without inviting the disaster of running into a corner.

Round barns tell traveling salesmen that this farmer is not going to be easy to trick with a standard bag of sales gimmicks.

People driving past a farm with a round barn get the uncomfortable feeling that somebody is trying to pull a fast one, but they can't put their finger on it.

Not even tornadoes know what to do with a round barn.

People who build round barns usually live long and casually, and always die with smiles on their faces.

Goddess of barns, Millville, Iowa, 1999

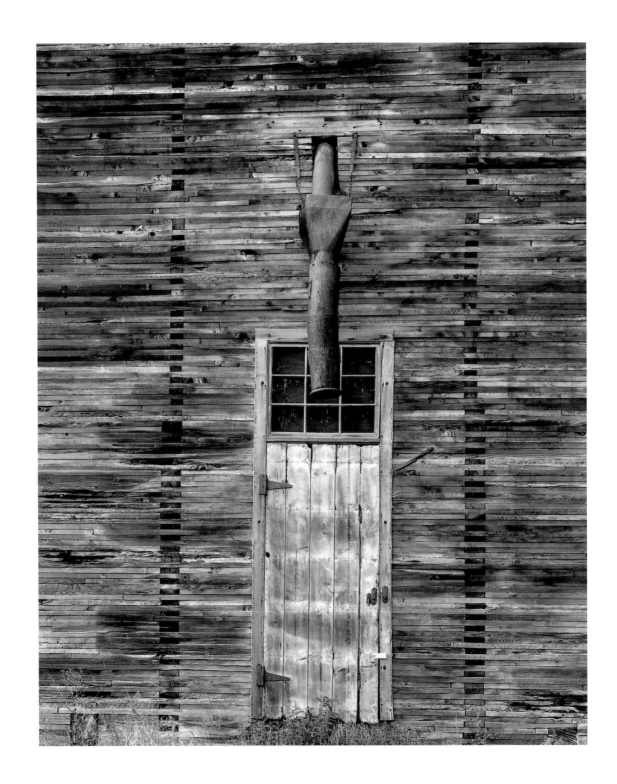

Grain elevator,
Amana, Iowa,
1995

20

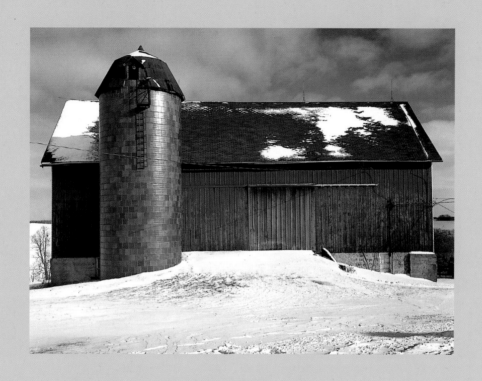

Barn façade with berm and silo, Dubuque, Iowa, 1999

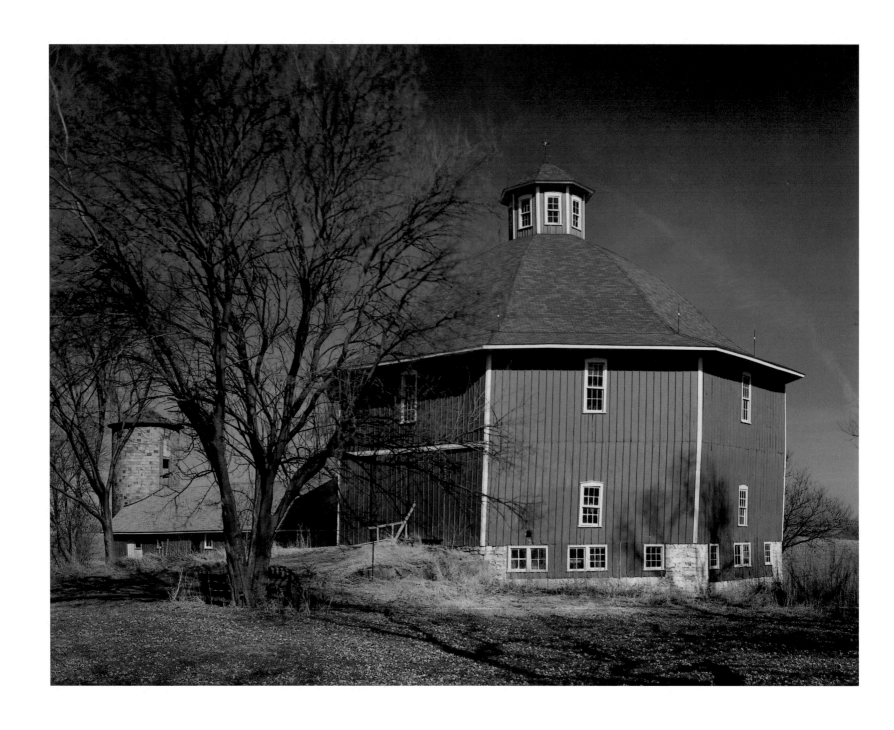

Octagon with cupola, Downey, Iowa, 2000

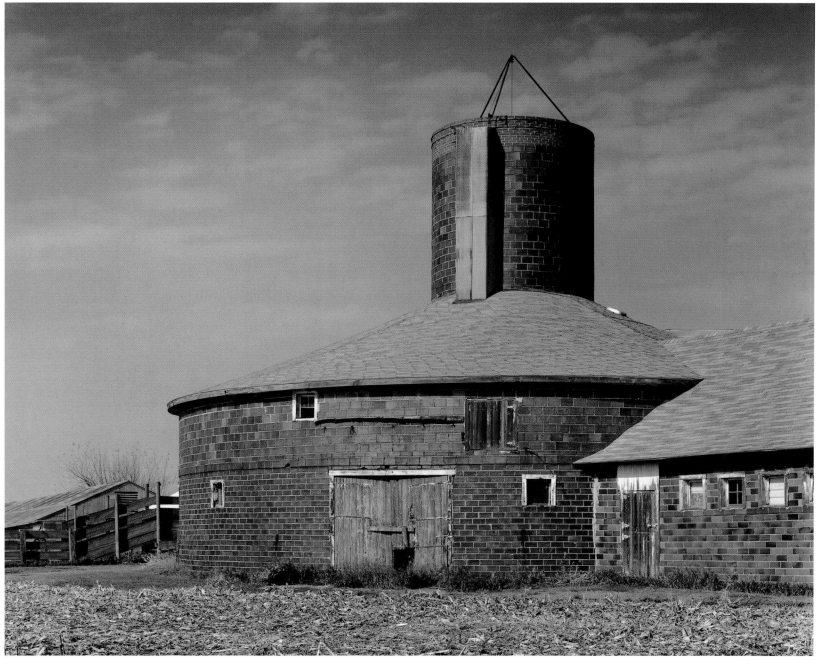

Round barn with silo, Dysart, Iowa, 2000

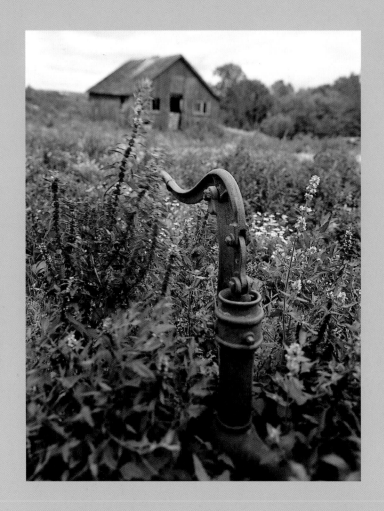

Hand-pump on farm, Clutier, Iowa, 1994

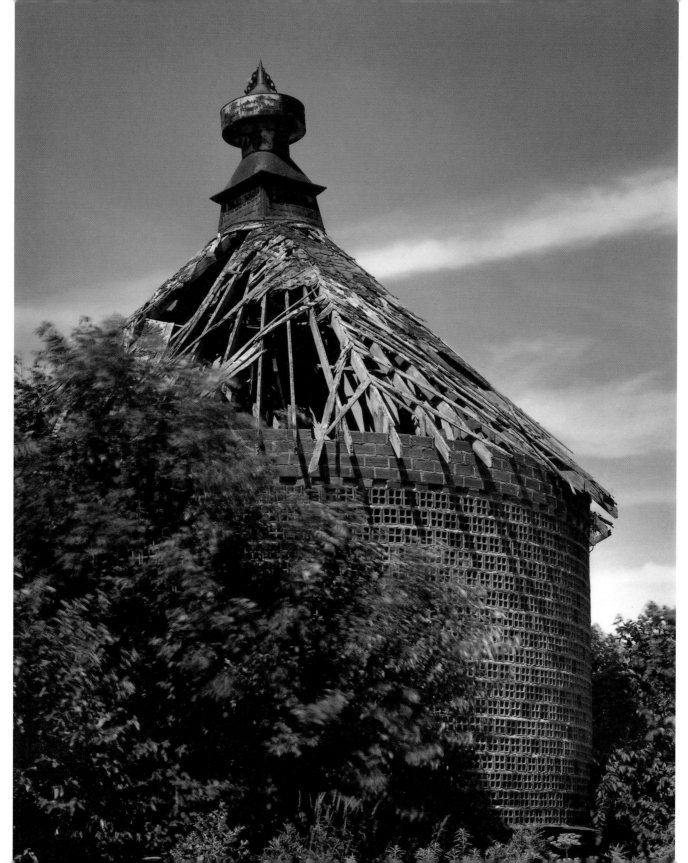

Corn crib,
Riverside,
Iowa, 1998

25

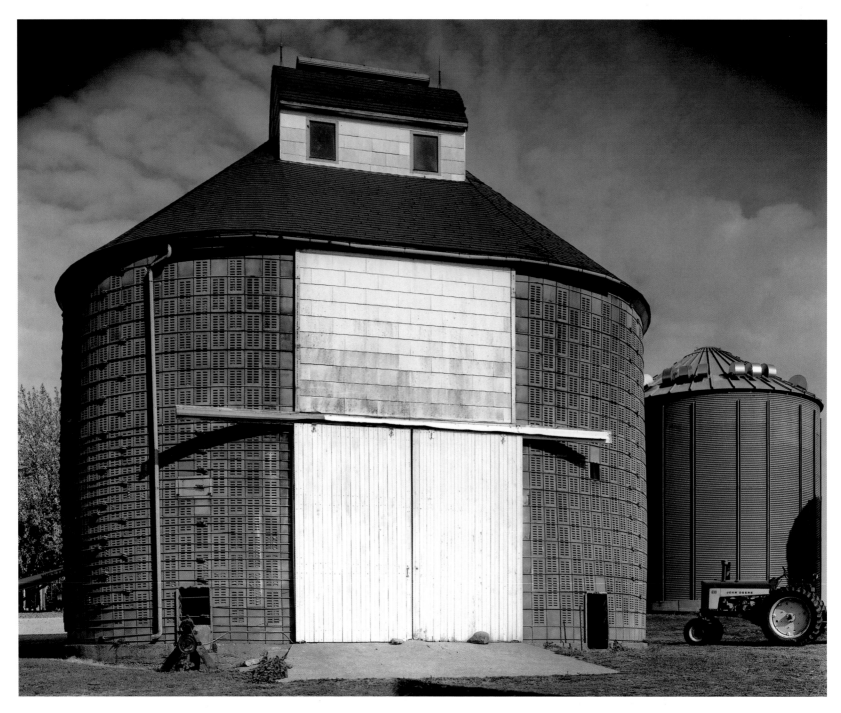

Silos and tractor, Clutier, Iowa, 2000

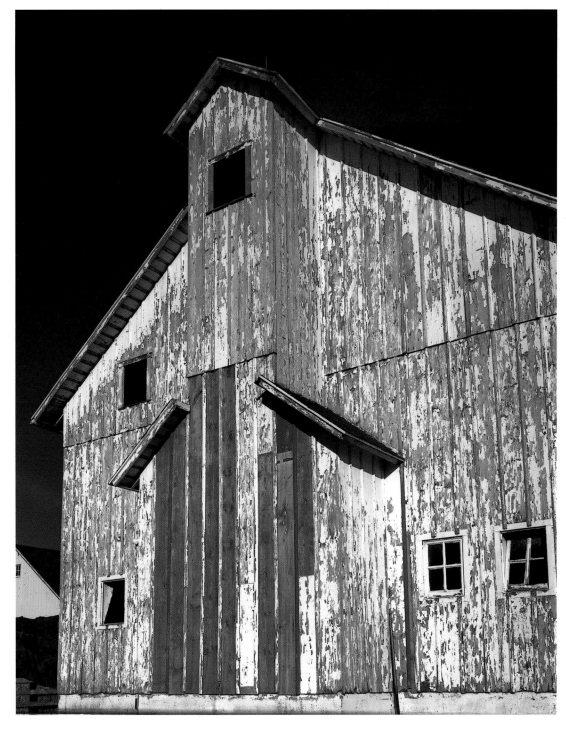

Horse barn,
Bennett, Iowa,
1999

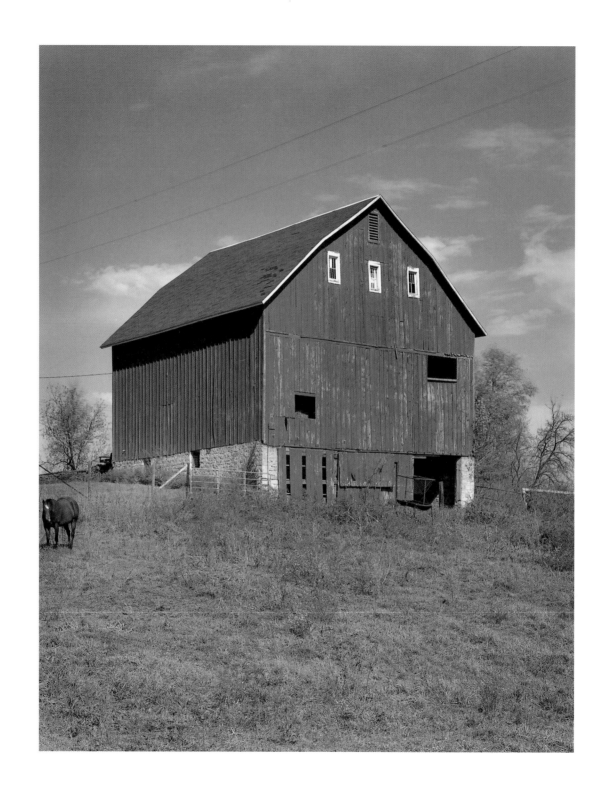

Horse
barn no. 2,
Ely, Iowa,
1999

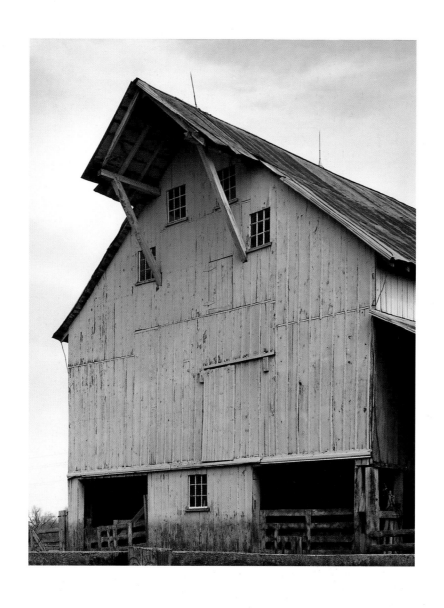

Cow barn no. 2, High Amana, Iowa, 2000

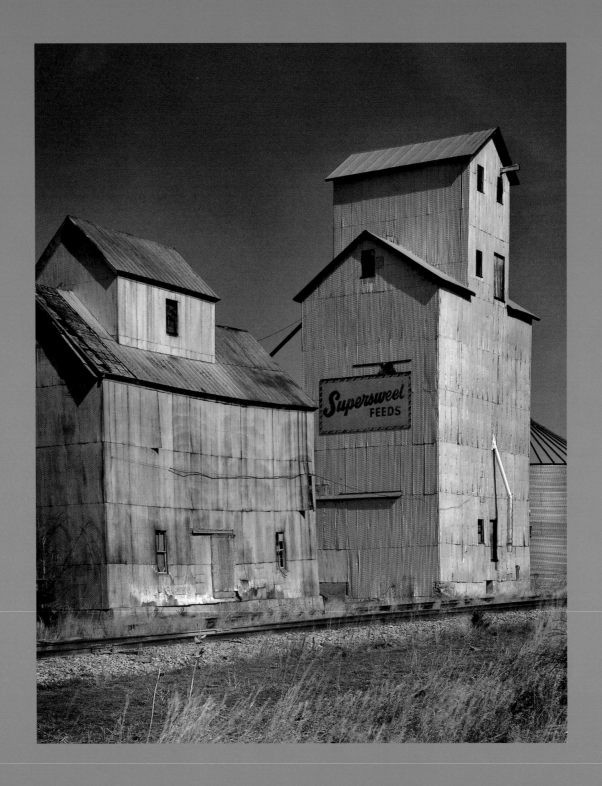

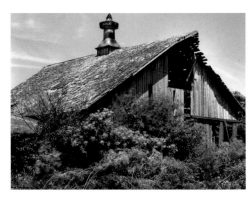

One could argue that a corrugated metal roof on an old barn that has doweled joints and heavy-timber rafters is no worse than a toupee on a bent seventy-year-old man. One could argue that tar paper over leaky spots in an old wooden-shingle roof is no worse than a heavy coat of rouge on an old woman's facial blemishes. And one could certainly make a case for putting steel jacks in place of wooden posts that are about to give way: isn't that a little bit like a hip replacement? But an aging barn with any imagination at all knows the real solution to aging is *tattoos*! Any colorful old sign will do! License plates will do! Road signs! Feed decals! – and don't forget Red Man Chewing Tobacco!

Elevators, Downey, Iowa, 2000

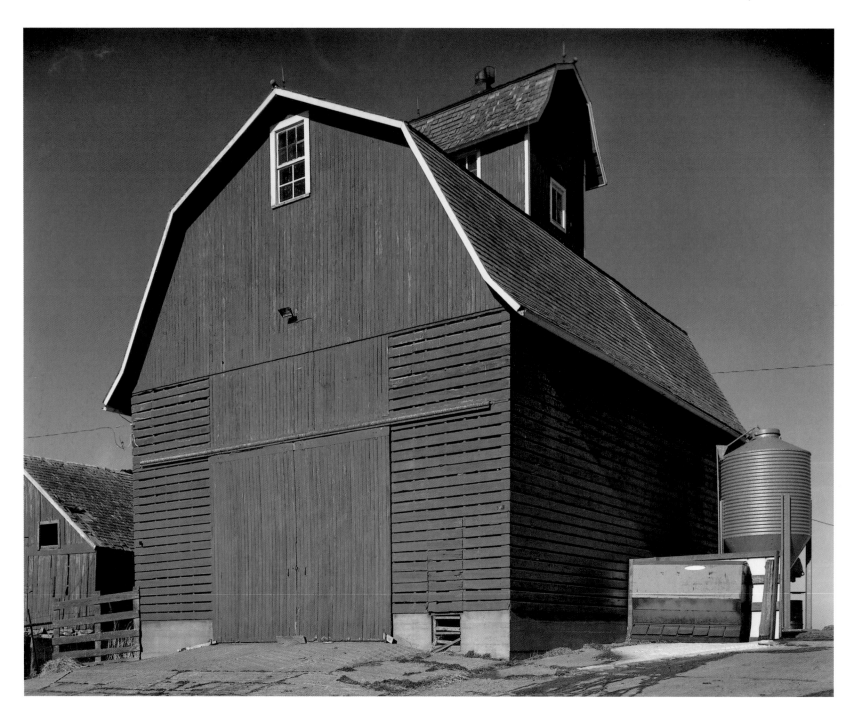

Kevin Doyle's corn crib, Monticello, Iowa, 2000

32

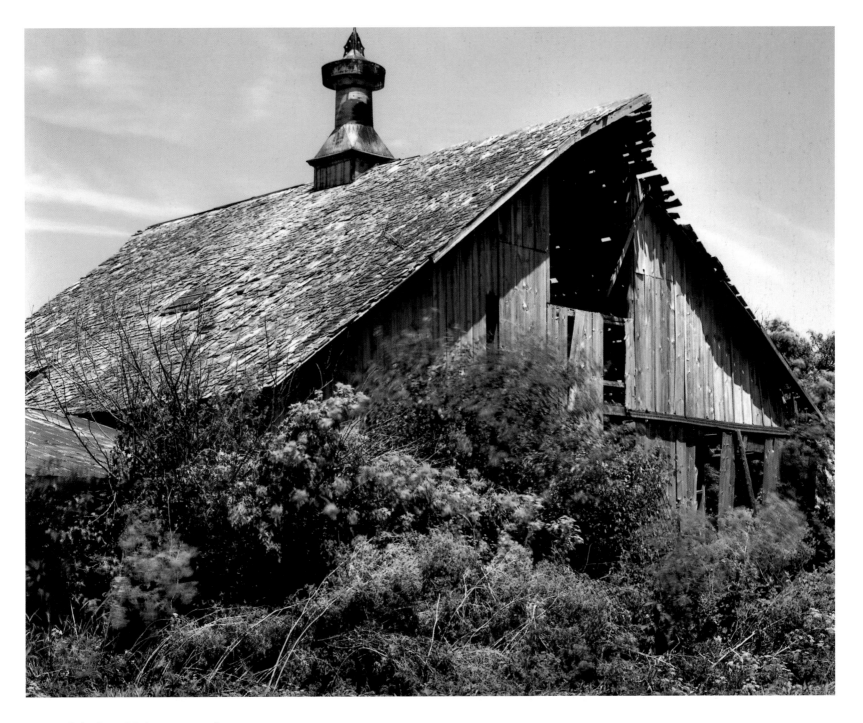

Barn and shrubs, Nichols, Iowa, 1998

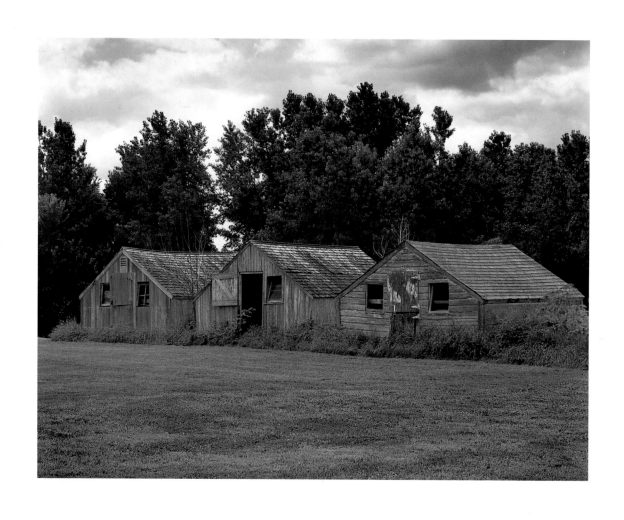

Baby barns, Chickasaw County, Iowa, 2000

10. Individuals drinking first alcoholic beverage—22

11. Individuals experiencing first romantic encounters—22

12. Fist fights involving two individuals—9

13. Fist fights involving more than two individuals—4

14. Father-daughter arguments—16

15. Husband-wife arguments—2

16. Father-grandfather arguments—38

17. Father-son arguments—3,189

18. Games of tag—610

19. Games of hide-and-seek—350

20. Other games, including basketball on empty haymow floor—998

21. Broken arms—2

22. Concussions—8

23. Private weeping by one individual—77

24. Private praying by one individual—16

25. Group revival meetings—1

Note: The journal had a total of 720 entries, some of them too shocking or private to record on these pages, some of them seemingly insignificant but evidently important enough for the barn to record, for example: "Number of times doors left unlatched to blow mercilessly in the wind—1,106." In any event, the editors have decided that some things are too personal to print.

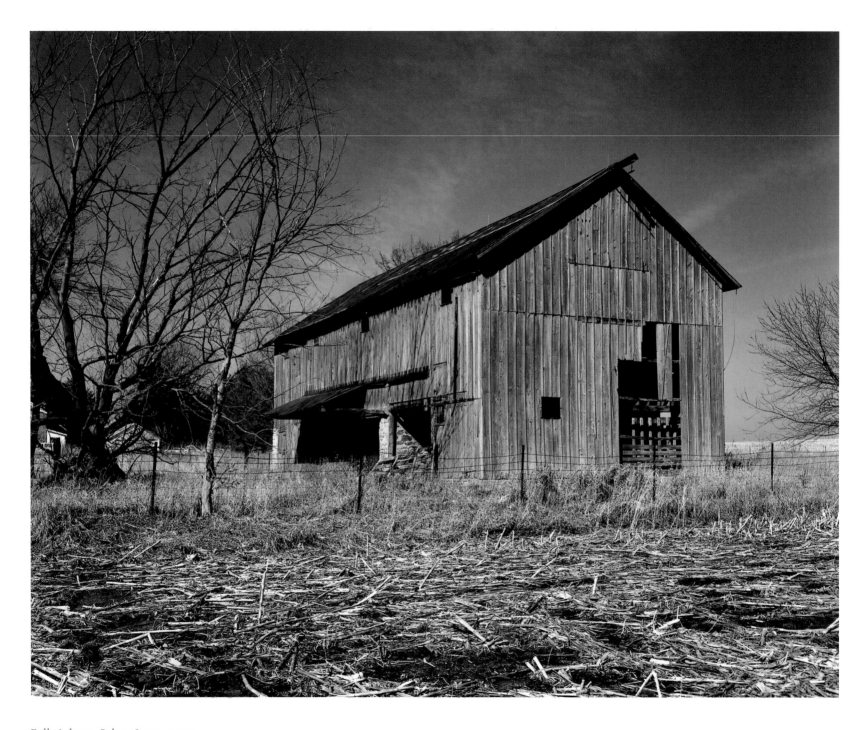

Fuller's barn, Solon, Iowa, 2000

44

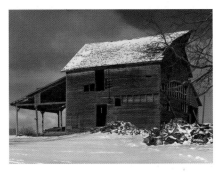

Some barns look as if they were born tired, as if they never really stood up from a seated position. Squat barns. Staying close to the earth. Barns that were born ducking storms, ducking trouble. Barns that don't like trouble at all. Barns that don't fight back when you close their doors, don't fight back when a steer walks through their wide alleys. Tired barns with weeds growing around their ankles, barns so tired they make the weeds around their ankles look tired too, make the weeds droop, make the drooping weeds hang there like socks that have lost their elastic. Tired barns with sway backs and no gumption. Barns so tired they never close their hay doors. So tired that the cows inside yawn all day long and forget to go out to pasture. Limp, tired barns, so tired that nothing bad ever happens to them. The nails don't even pull out of the siding. The shingles don't even fall off. The windows are so dirty that no one ever looks inside to see if anything is happening, and because nothing is happening the tired barns go on comfortably listless. Like park benches that nobody ever sits on. Barns so tired that snow feels like a blanket, so tired that rain feels like a bath, so tired that wind feels like a massage. Ignored, tired barns that go on and on and on, like a lazy person who's never done a day's work, never had a job, never had a worry, just sits in an easy chair chewing on a cigar, not needing much of anything, and living to be a hundred and twenty.

1870s era barn, Dubuque, Iowa, 1999

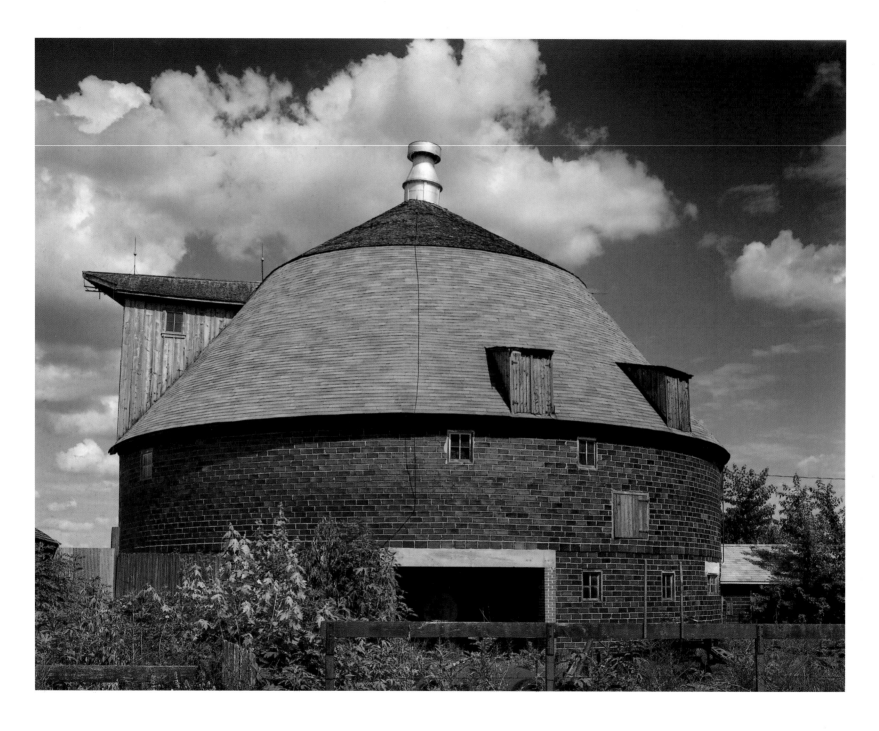

Canfield's round barn, Dunkerton, Iowa, 2000

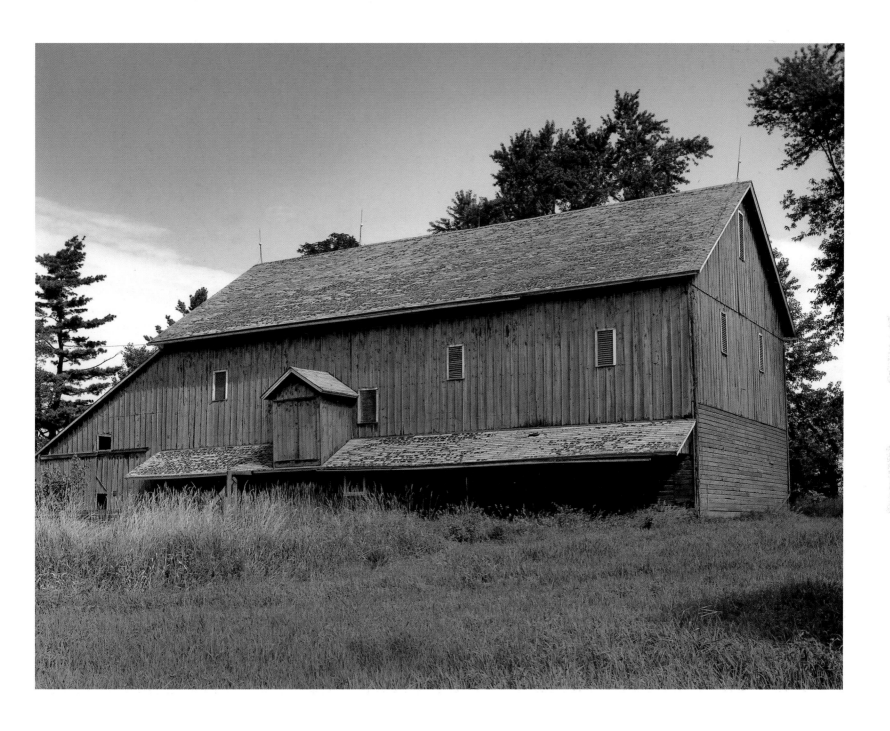

Long barn, North Liberty, Iowa, 2001

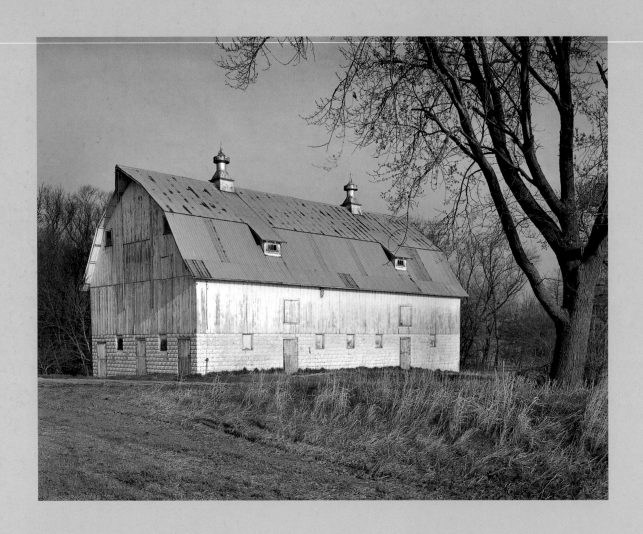

Barn and trees, Cedar Rapids, Iowa, 2000

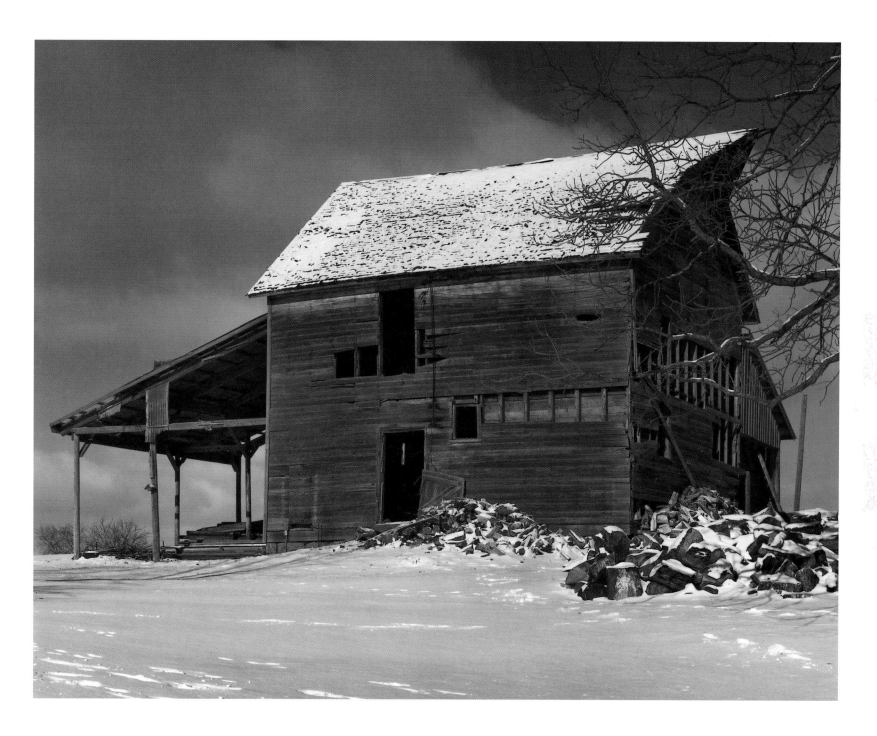

Barn with firewood, Dubuque, Iowa, 1999

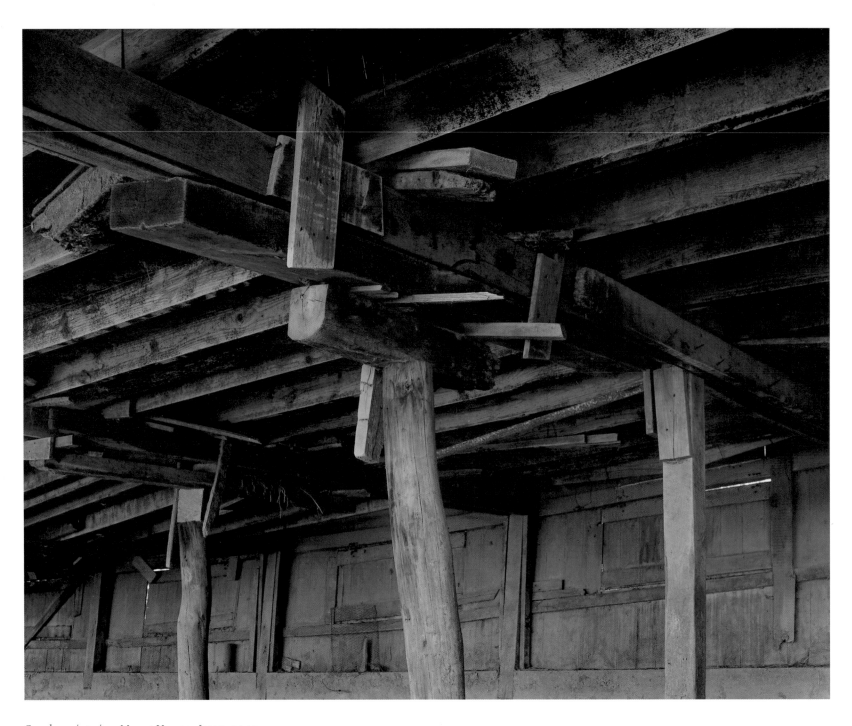

Cow barn interior, Mount Vernon, Iowa, 2001

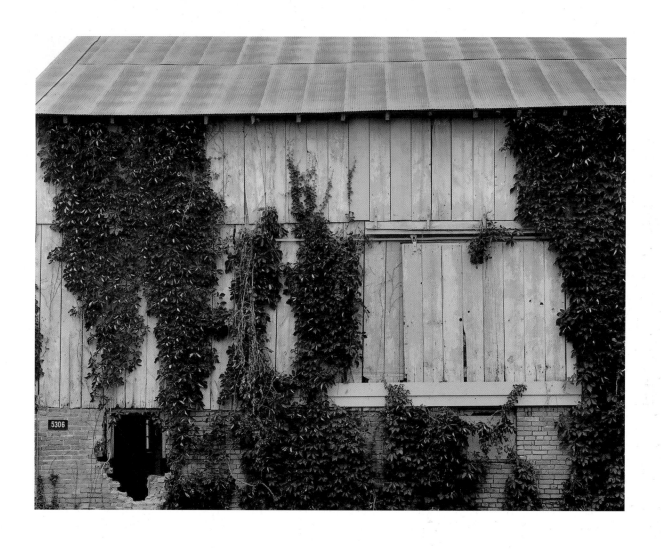

Barn and vines, West Amana, Iowa, 1997

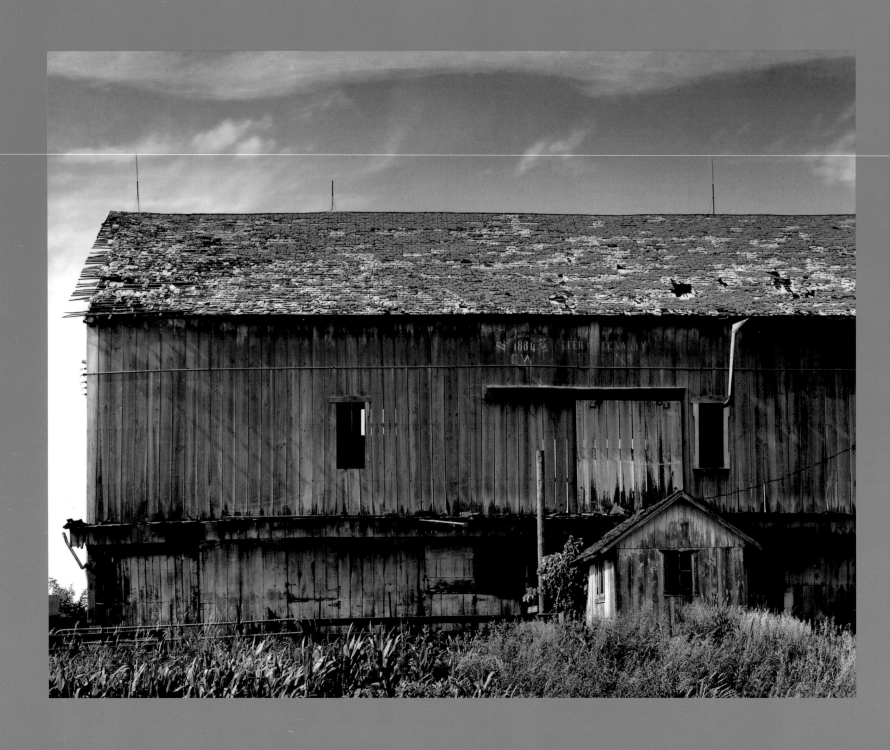

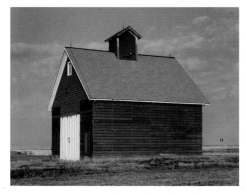

Somebody was in a hurry. You can almost hear him: "We've got to get this thing built before winter!" You can still see the marks of reckless intention eighty years later. Nothing was put on quite straight. Or ideas changed in mid hammer-blow and the barn suddenly veered off in a new direction. First one add-on and then another until the poor barn was one big hodgepodge, looking like somebody who couldn't decide if they were hosting a birthday party or a funeral. A barn with tributaries. A barn with loose strands. A barn with multiple personalities.

We should give the confused barn a break. It is like a child whose parents were not consistent. Or maybe one parent was permissive and spontaneous while the other was strict and repressive. Pretty soon the barn had no sense of itself and was, as they say, scarred for life. Even today it stands awkwardly in the world like an aging wayward child.

Of course, we can't be sure the fault lies with the birth-parents, those first builders who wouldn't have known a blueprint if they were standing on one. Perhaps the barn was adopted by new parents who had a completely different idea of how a barn should be – or should have been – raised. But what does it matter? It's all history now. What we're left with is an old and confused barn.

Do not be cruel to the confused barn. Be gentle. It was not the barn's fault. It was a victim when it was young, and it still is. The least we can give it in its old age is our kind understanding and a forgiving eye.

Façade 1884, Wellman, Iowa, 1998

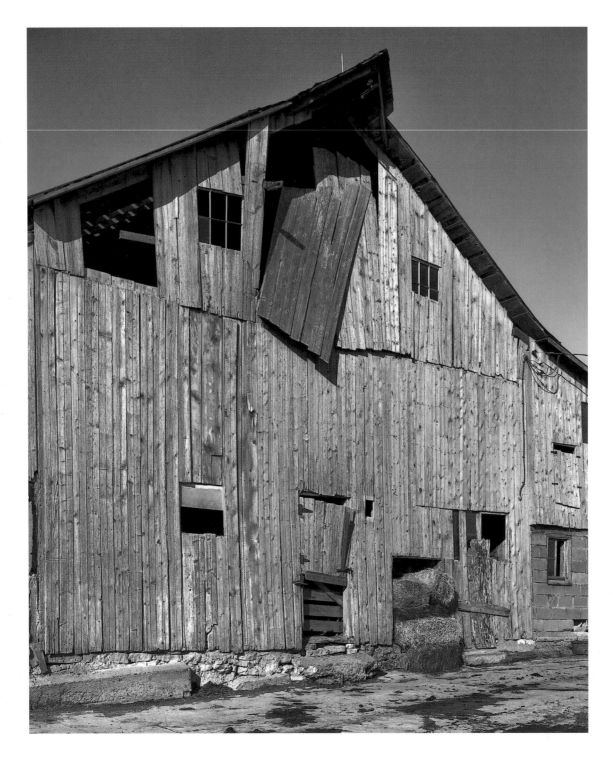

South façade no. 3,
Monticello, Iowa,
2000

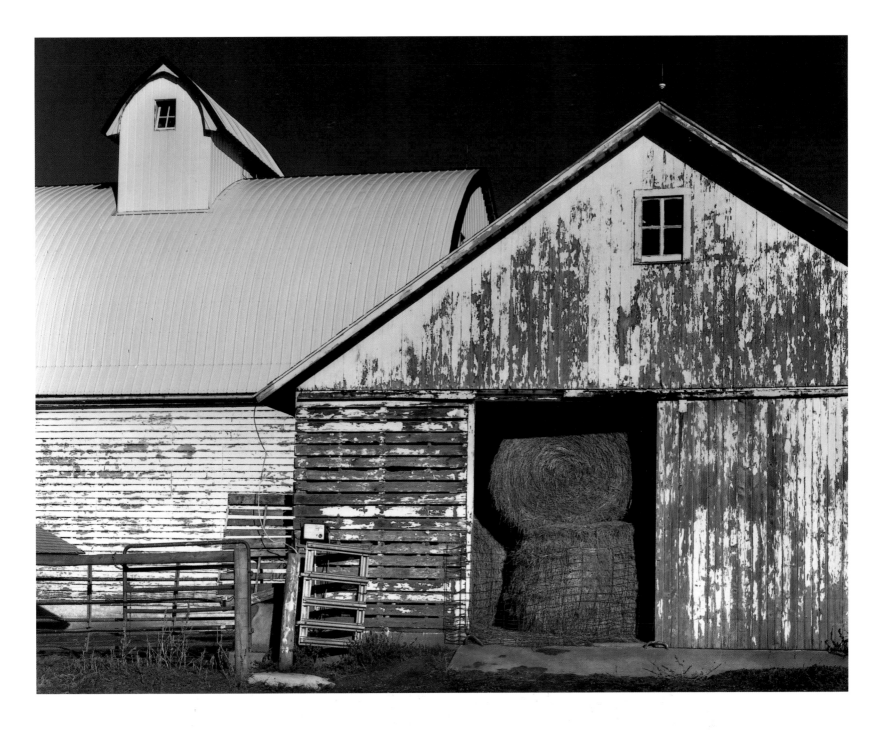

White barn and hay bales, Bennett, Iowa, 1999

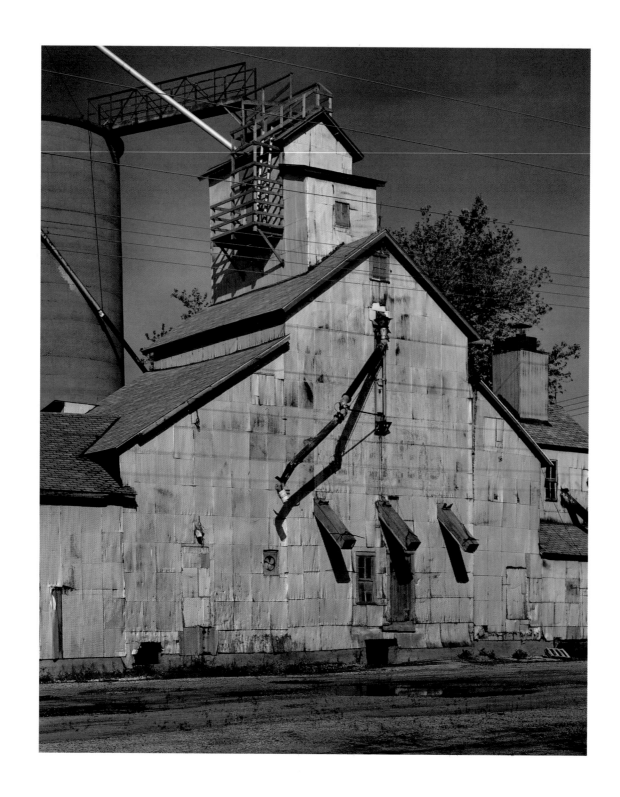

Ely grain elevator, Ely, Iowa, 2001

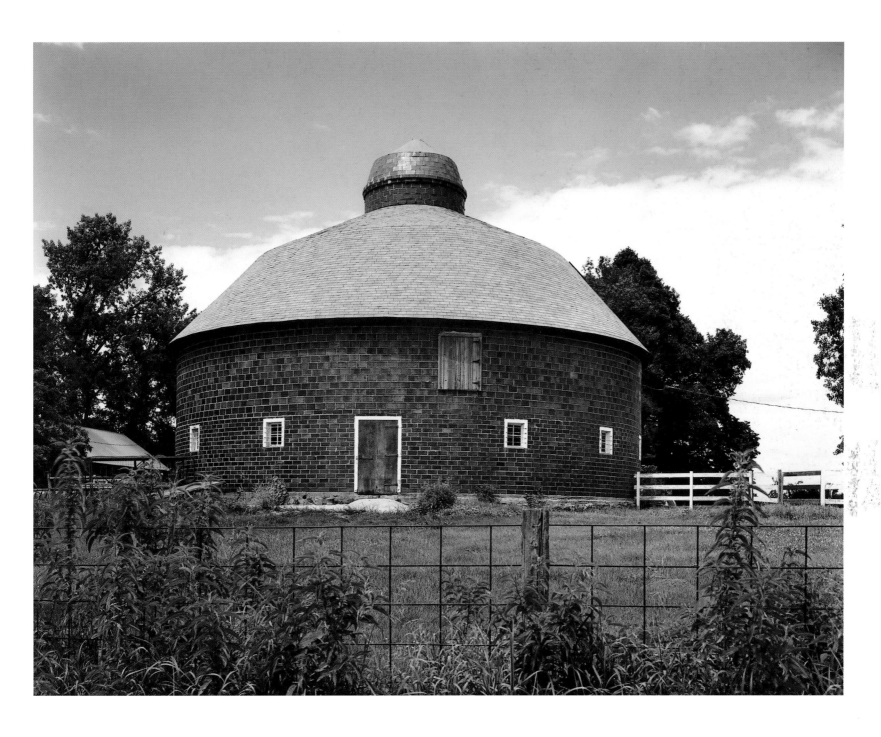

Jim Hundley's round barn, Waverly, Iowa, 2000

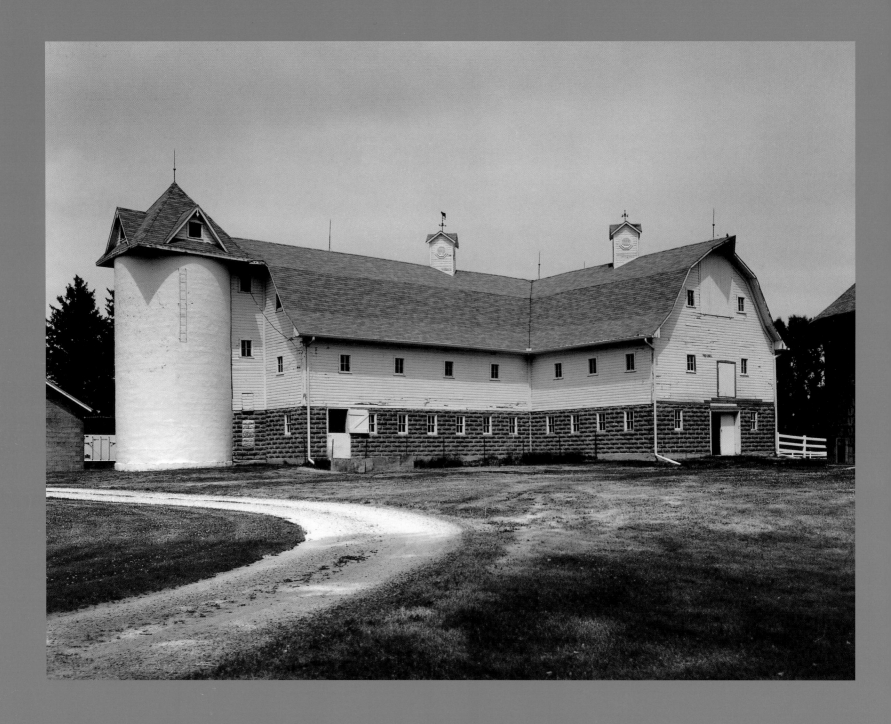

I have never been able to trust a haughty barn, especially a smooth-bricked one that rises into a hipped roof on which are perched gratuitous dormers with multipaned windows. There is a frivolous worldliness to these haughty structures. Barns should epitomize humility, sacrifice, and longsuffering. Vanity of vanities!
—From a rural Iowa preacher's notebook, circa 1959

The arrogant barn interrogates its viewers, asks them in less-than-polite terms what their station in life might be. If you see an arrogant barn, you usually see a painted white fence trailing from the foundation like a queen's robe. One cupola is not enough for the arrogant barn. It likes at least two, maybe three – more cupolas than a Trident submarine has periscopes. The cupolas gleam silver in the sunlight like overpriced jewelry.

What happens inside the arrogant barn, this structure that looks as if it were built for a movie set? Do the cows wipe their feet on clean straw before entering the side door every night at exactly five o'clock? Does the farmer wear a suit and tie and enter with a short black whip to make everything jump for him? Is the wealth that built the arrogant barn well-earned wealth, or is it show-off money that came from some mysterious source? The arrogant barn does not look democratic. It looks as if it would prefer to live in an era of knights and ladies. And servants. Or at least on the covers of slick country-living magazines.

But ah, age – that kind equalizer of age! Old arrogant barns wrinkle and submit, gain humility, become friendly in demeanor. The pretense falls away as the shingles loosen, the lightning rods rust, and the white fence crumbles. In old age, the arrogant barn joins its contemporaries. The landscape is like a huge nursing home, everyone equal, all given their own space to crumble graciously, like humans, going to their long home.

Barn and silo, Grundy Center, Iowa, 2001

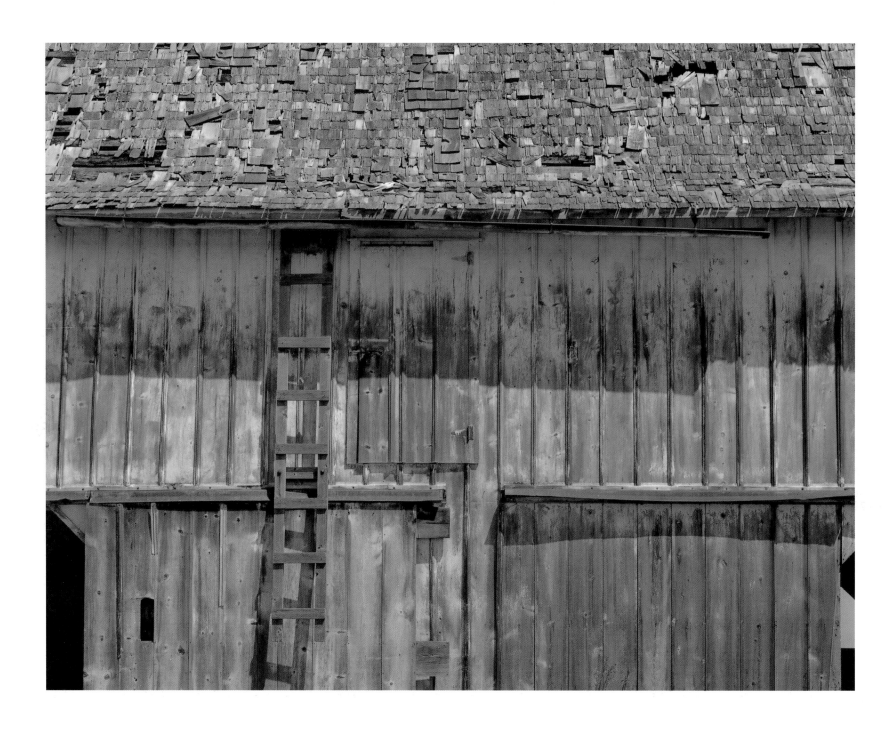

Barn detail no. 1, Linn County, Iowa, 2001

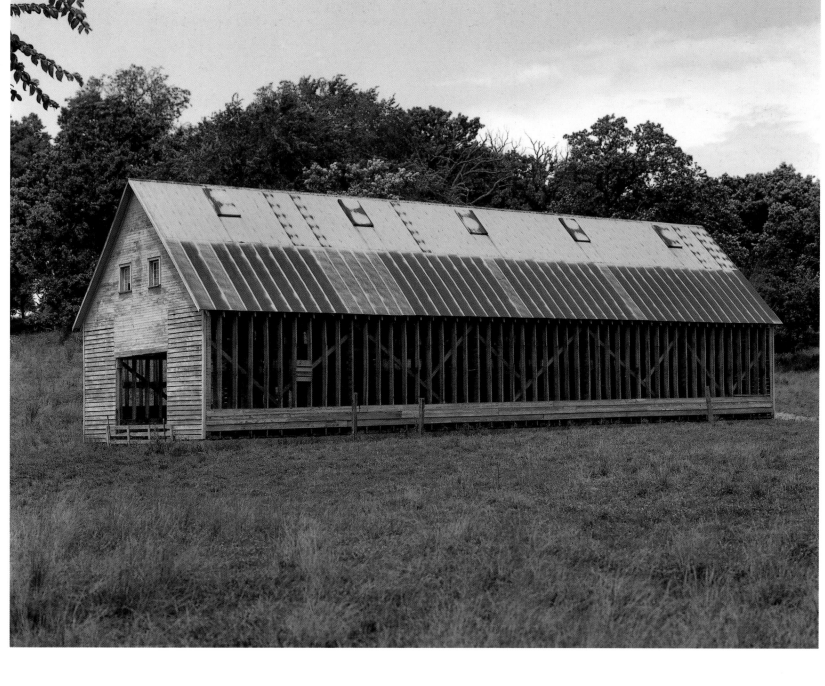

Corn crib, West Amana, Iowa, 1995

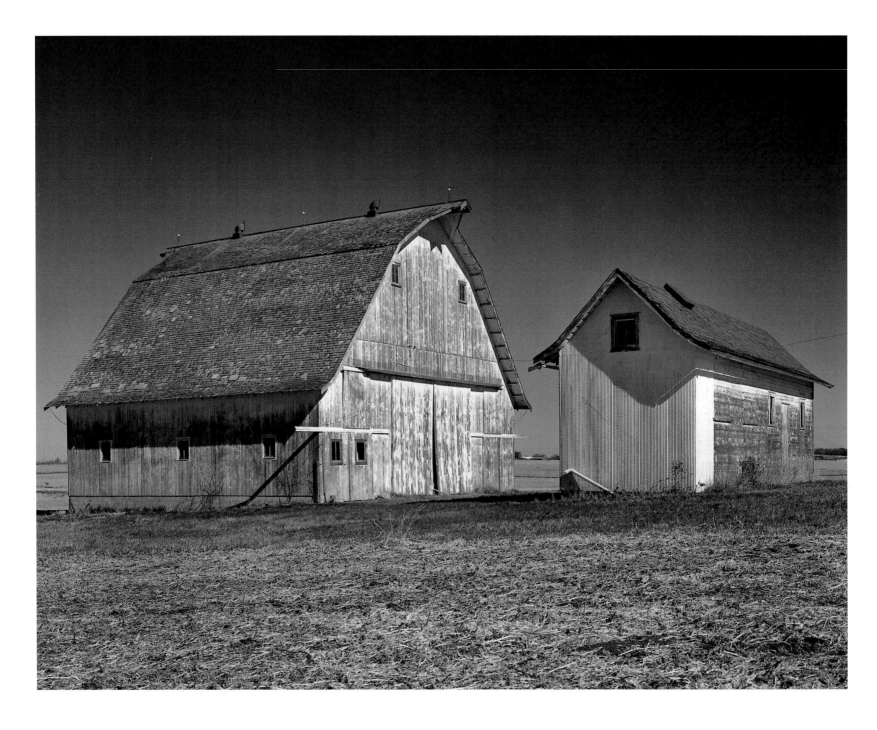

Barn and shed, Mount Vernon, Iowa, 1999

76

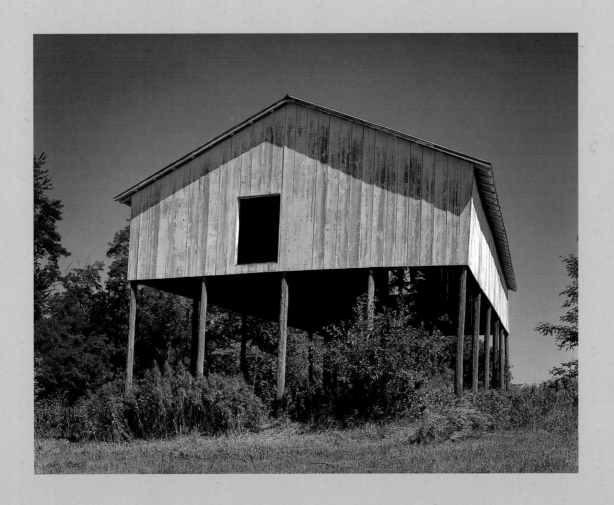

Hay barn on stilts, Morning Sun, Iowa, 2001

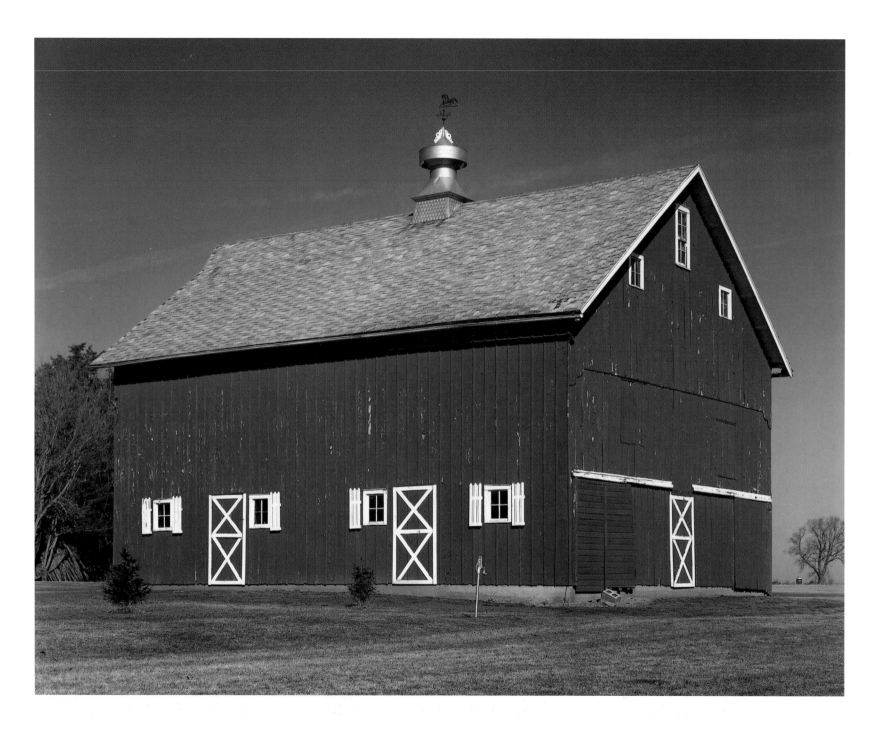

Barn with crossed doors, Solon, Iowa, 2000

78

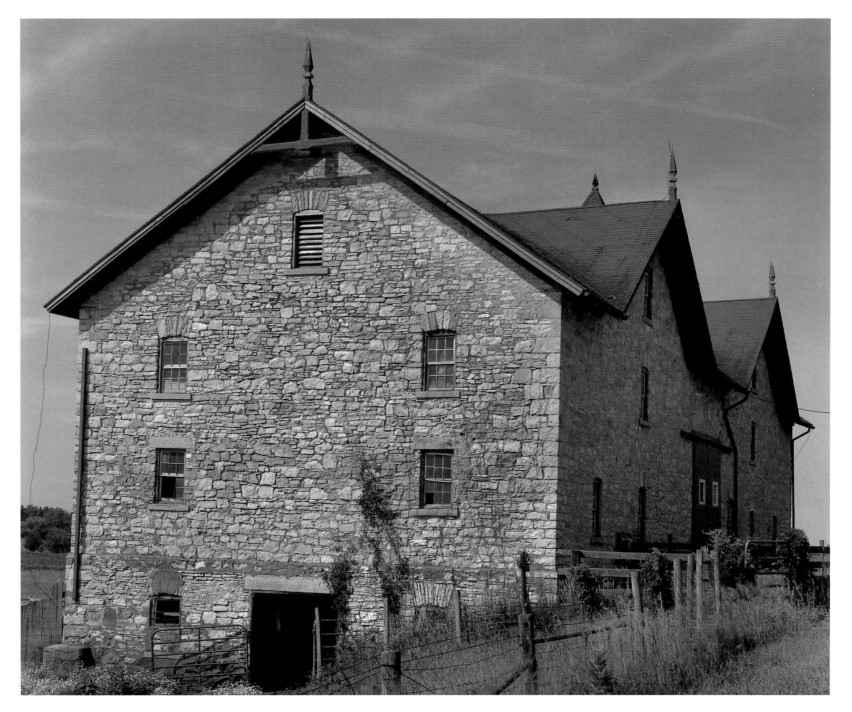

Limestone barn no. 2, Cedar Falls, Iowa, 2001

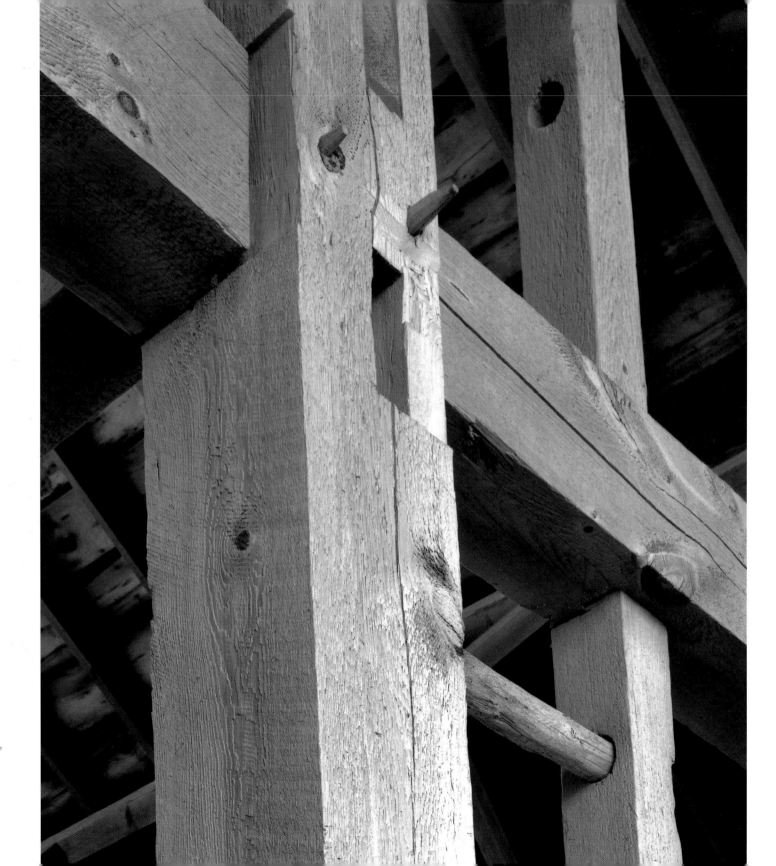

Support
beams,
Washington,
Iowa, 2000

80

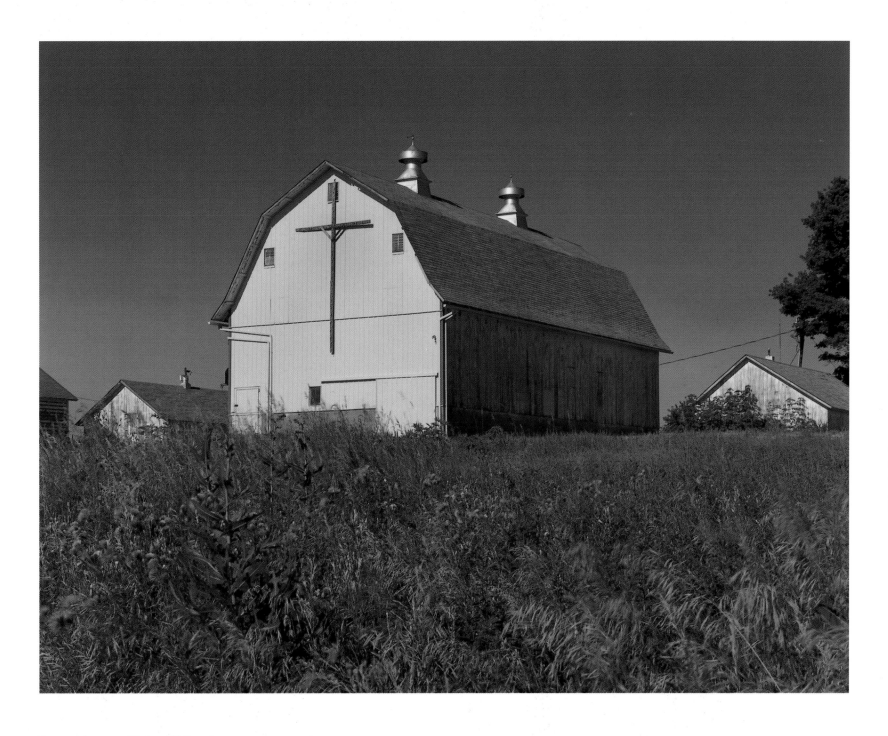

Barn with cross of lights, Walker, Iowa, 2000

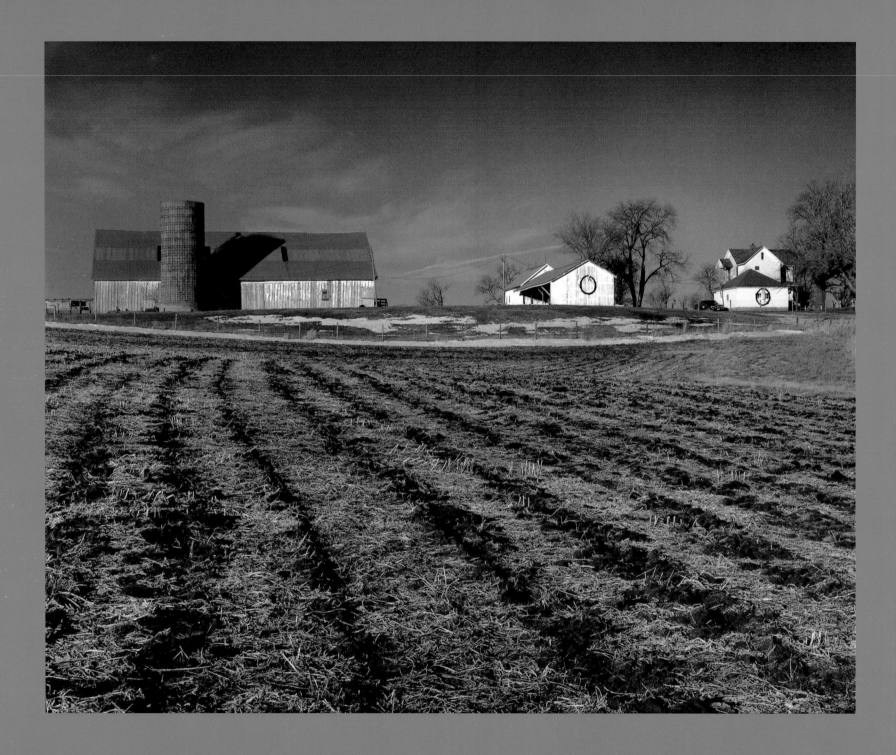

WHAT THEY WERE PROBABLY WONDERING WHEN THEY BUILT THE BARN

If we put the barn here, will we still be able to see the sunrise from the house?

Is this close enough to the house so we won't have to spend all day shoveling a path in the winter?

Is this so close to the house that we'll smell cow manure in the kitchen?

Think there could ever be a flood that would get this high?

Is this design easy enough so that the carpenters will know what they're doing?

If we put this door here, will we be able to see the cows in the pasture as we stand here?

Will this manger be high enough to keep a wild calf from jumping over it?

Does it have any doors where you could stand during a rain storm without getting wet?

What animals will we put on this cold north side?

Think this window sill will be big enough for a cat to sit on?

Could a bull knock that support post out?

Is that door big enough for a pregnant horse?

What could we do to make that ladder safer for kids?

Think we need store-bought latches, or could we make them out of scrap wood?

Think a four-year-old could reach this latch if we put it this high?

Will the cupola be higher than the one on the neighbor's barn?

Field and barn, Tipton, Iowa, 1999

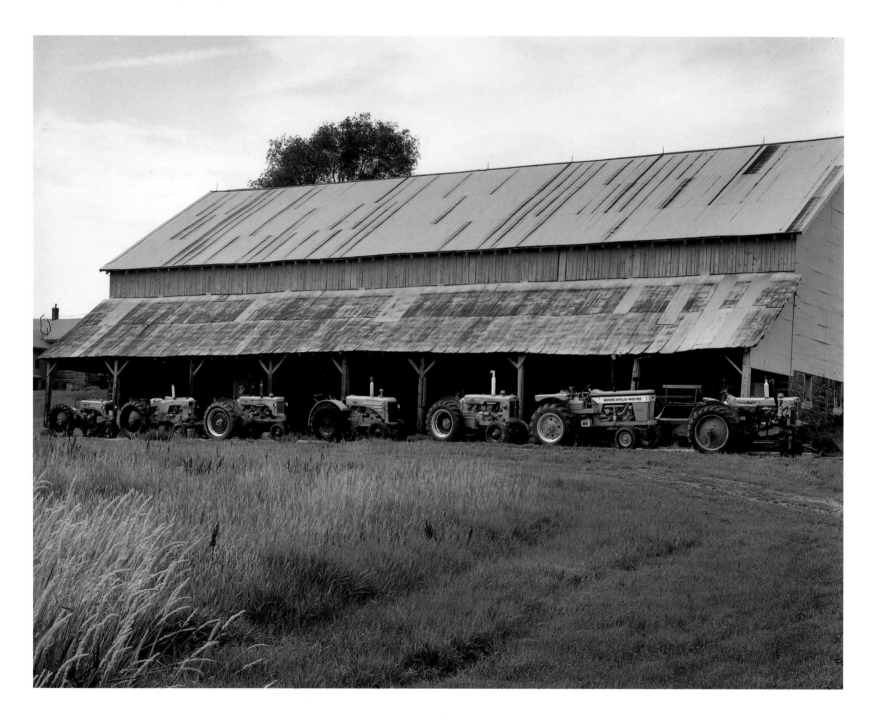

Tractors, West Amana, Iowa, 1995

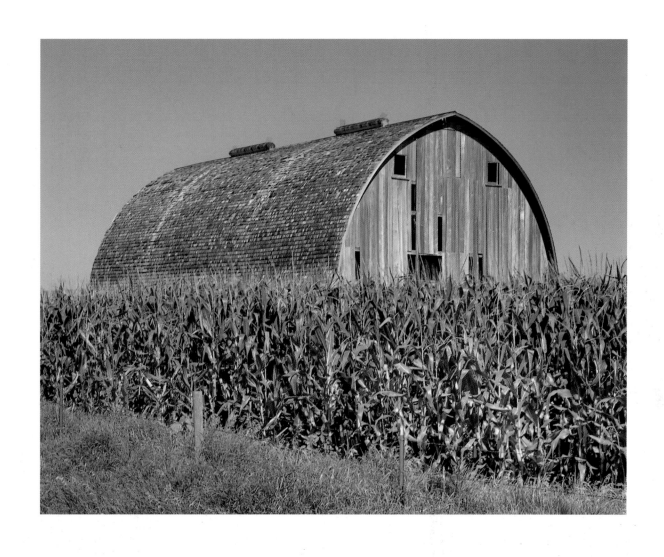

Barn in cornfield, La Porte City, Iowa, 2000

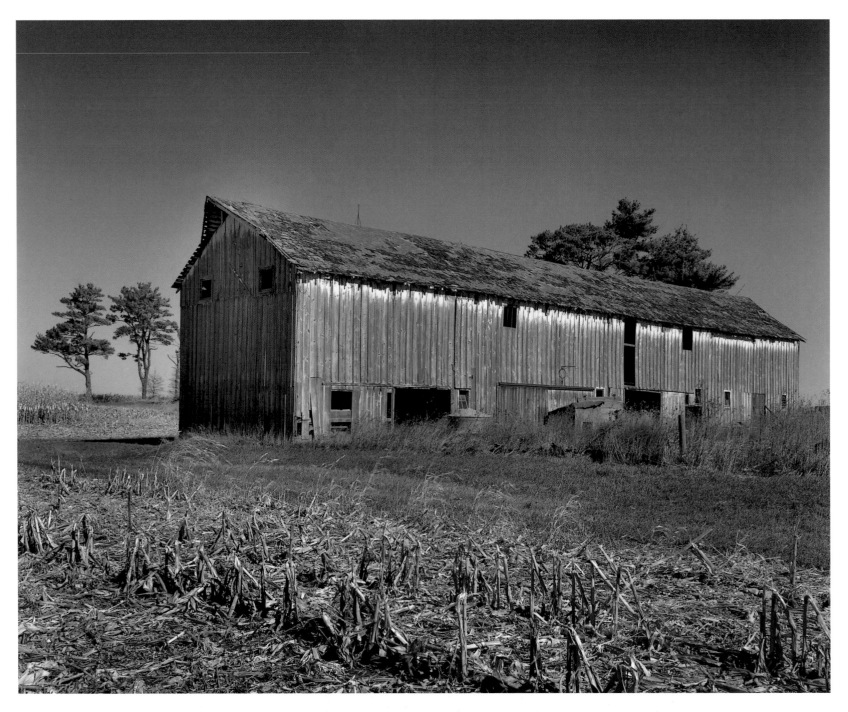

Barn ark, Jones County, Iowa, 1999

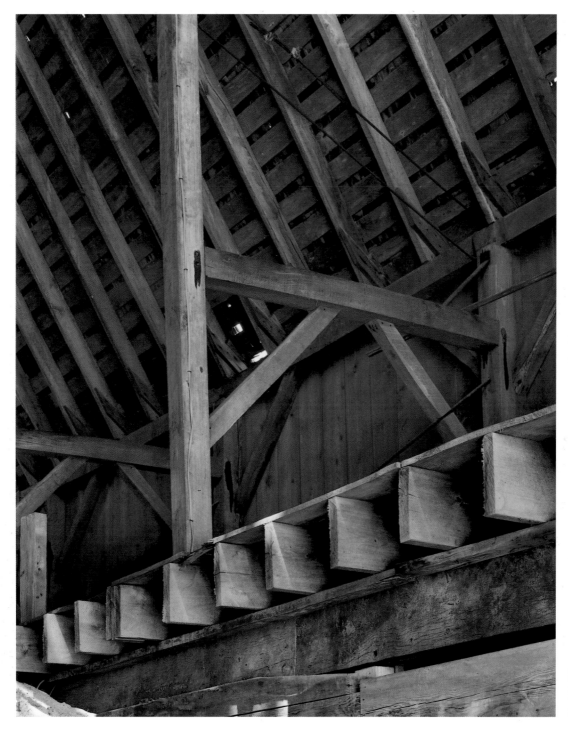

Interior,
Linn County,
Iowa, 2001

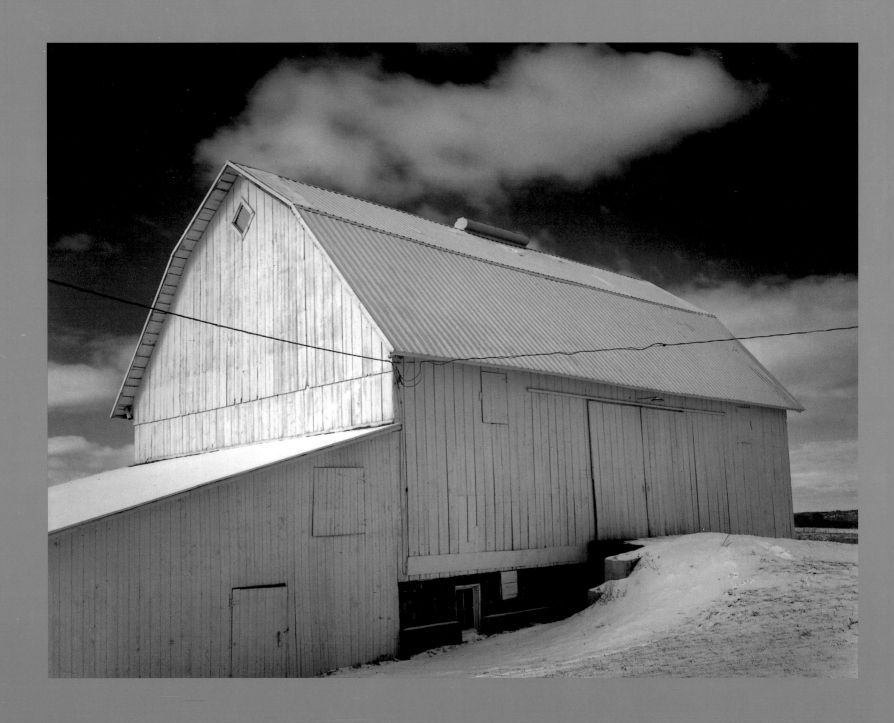

White barn no. 1 in snow, Dubuque, Iowa, 1999